Drawing Birds

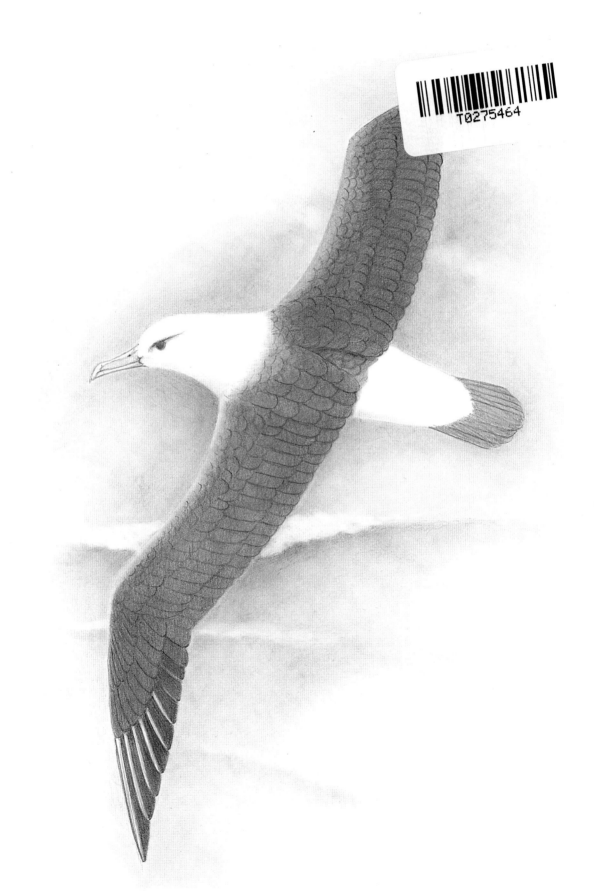

Dedication

To my family

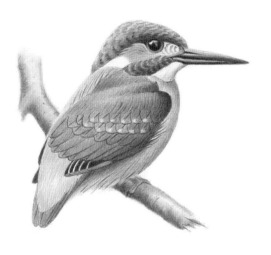

Drawing Birds

Andrew Forkner

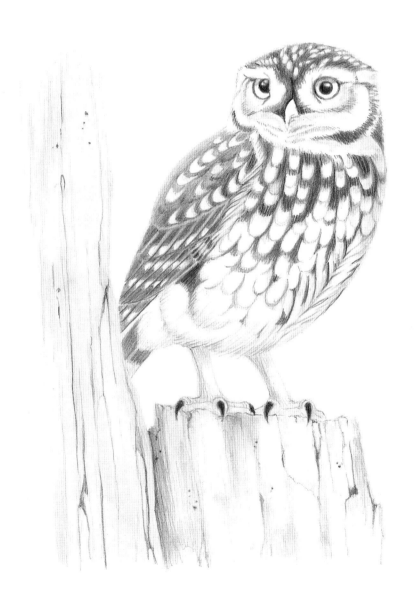

SEARCH PRESS

Contents

First published in 2018

Search Press Limited
Wellwood, North Farm Road,
Tunbridge Wells, Kent TN2 3DR

Reprinted 2019, 2021, 2024

Photograph on page 18 by Andrew Forkner

Illustrations and text copyright
© Andrew Forkner 2018

Photographs (except page 18) and design copyright
© Search Press Ltd. 2018

ISBN: 978-1-78221-492-2

The Publishers and author can accept no responsibility for any consequences arising from the information, advice or instructions given in this publication.

Suppliers
If you have difficulty in obtaining any of the materials and equipment mentioned in this book, then please visit the Search Press website for details of suppliers:
www.searchpress.com

You are invited to visit the author's website:
www.andrewforkner.co.uk

Acknowledgements

I would like to offer my grateful thanks to the following members of the team at Search Press for their involvement with this book:

Katie French for her enthusiasm and support for this project;

My editor, May Corfield, for her expertise and guidance throughout the whole process;

Juan Hayward and his team for their superb design input.

Front cover
Golden eagle

Page 1
Black-browed albatross

Page 2
Kingfisher

Page 3
Little owl

Opposite
Canada geese

All drawings in the book are graphite pencil on 250gsm (115lb) Bristol board.

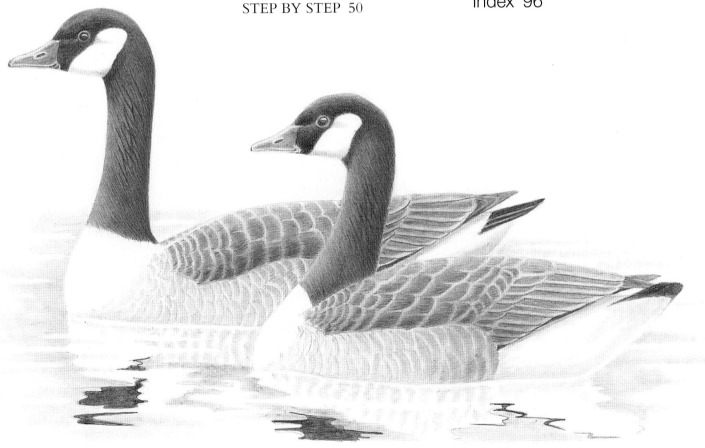

Introduction

'I wish I could do that.'

This is a statement that I hear repeatedly from people I meet during my demonstrations, talks and exhibitions. There are undoubtedly many people who have the desire to draw, but don't attempt it. This is often as a result of two overwhelming factors. Either they lack the confidence to try, or they are convinced that the ability to draw comes solely from some inherited 'talent', which they are convinced they do not possess.

My response to these people is always to point out that, in my opinion, they do actually already possess the one important requirement in order to learn to draw: the desire to do it! There is a saying that is most apt for this particular situation, which goes, 'Genius, that power that dazzles mortal eyes, is oft but perseverance in disguise.'[1]

All artists of whatever ability have to work hard to perfect their craft, so the fact that it may not necessarily come easily should not be taken as an indication that we 'can't do it'. You will be amazed at just what can be achieved by a little perseverance and hard work. However, in order to make the whole process as enjoyable as possible, it is important that we concentrate on subjects that really inspire us and it is for this reason that I have chosen birds as the focus for this book.

Many mammals can be secretive and elusive, often making encounters rare and fleeting, but all of us will encounter birds on a daily basis, whether in the form of visitors such as a blackbird or blue tit searching for food in our gardens, or ducks, geese and swans on the lake in the local park. Birds are everywhere and if we take the time to look more closely at these wonderful creatures, it will quickly become evident that they present us with an exciting and varied range of subject matter for our artwork.

Drawing birds successfully, as with any other subject, does not just require an understanding of the techniques and tools involved, but also a sound knowledge of the subject itself; so, as well as focusing on the important technical aspects of the creative process in this book, I have also included sections on the birds themselves. We will look at their important anatomical features and at birds in flight. There are also step-by-step demonstrations featuring a bird from each of the main representative groups.

The idea of drawing birds may at first seem a little daunting, but they are a subject that rewards practice and perseverance, so I hope that you find the information in this book helpful and encouraging.

[1] *Henry Willard Austin, American journalist and poet (1852–1912).*

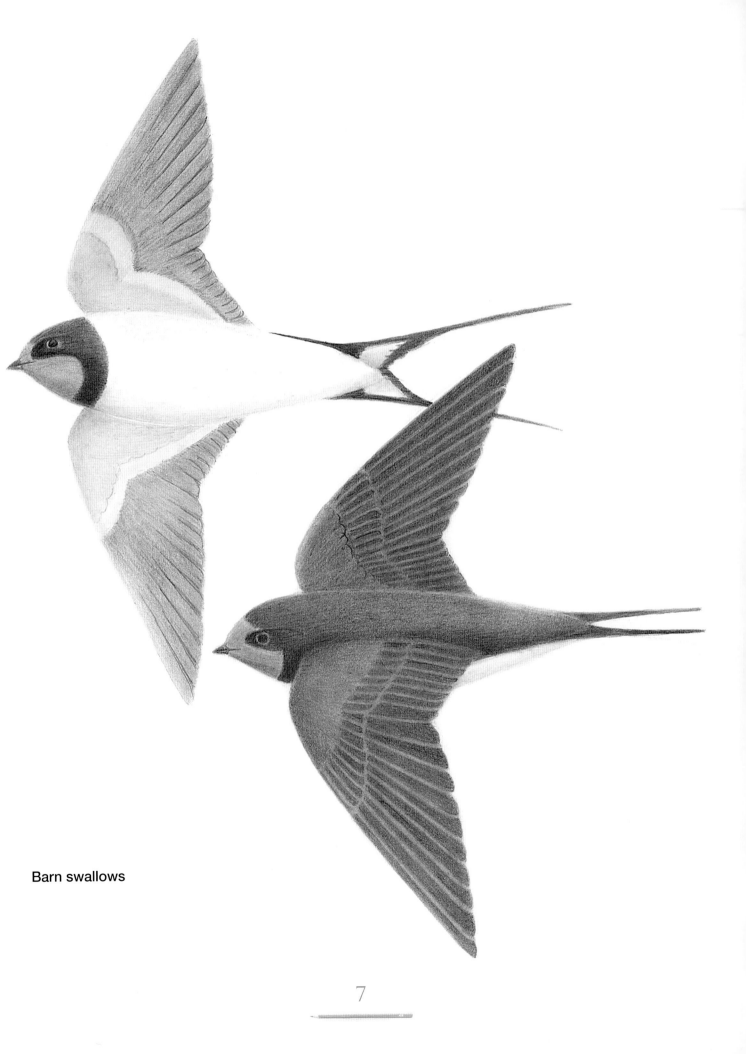

Barn swallows

The history of drawing birds

**Ancient Egyptian
representation of an ibis**

For centuries man has been fascinated by animals, both wild and domesticated, and has sought to produce artistic representations of the creatures that inspire him. In early history our cave-dwelling ancestors covered their cave walls with depictions of the animals that they encountered, but these images are usually of mammals and it is very rare to see birds featured among these paintings.

In ancient Egypt, images of birds were a little more common, both in their hieroglyphs and their art, with two of their deities – the gods Horus and Thoth – actually depicted with the head of a bird. Horus was depicted as a falcon, while Thoth had the head of a sacred ibis.

However, moving forward in time, as formal art began to be created to adorn the walls of grand houses and palaces and to illustrate books, birds were still not much in evidence. They could be found in some artistic work, but usually as dead game birds in still-life compositions, or as decorative additions to paintings featuring people and mammals. Rarely, if ever, were living birds the main subject in their own right.

By the time we reach the late 15th century, birds had instead become the focus of scientific study, as people began to explore the avian ability to defy gravity. The most notable of these investigators was Leonardo da Vinci, whose study of birds' wings and feathers gave rise to many of his revolutionary ideas. Some of these subsequently resulted in man's successful, if somewhat crude, attempts to take to the air.

In the 16th century the artist Albrecht Dürer, who is particularly known for his drawings and prints, did create some studies of birds, but he more usually chose to focus on illustrations of the human form and on a series of drawings featuring fantastic imaginary creatures. It was not really until the 19th century that artists finally began to appreciate the artistic potential of depicting birds and an explosion of bird art began to take place.

During the 1800s, interest in the natural world was stimulated by the voyages of the English naturalist and geologist Charles Darwin. On these expeditions Darwin was accompanied by an artist called Conrad Martens, whose job it was to record, in pencil and watercolour, the diversity of wildlife that they encountered, thus raising public awareness of the beauty of the natural world. That awareness was then further increased by the work of two ornithologists, who both happened to be skilled artists. The two men in question were the American, John James Audubon, and an Englishman, John Gould, who was heavily influenced by the work of Darwin. For the first time here were two accomplished artists who chose to depict birds as the dominant subjects in their paintings. Their interest in ornithology meant that each wanted to depict his bird subjects as part of the natural world and they often placed them in authentic, detailed backgrounds.

In the first half of the 19th century Audubon created a set of paintings entitled *The Birds of America*, which were then reproduced as copperplate etchings, individually hand-coloured using watercolour. This process was repeated using lithographic plates by John Gould during the latter half of the century as he completed his book, *The Birds of Great Britain*.

Immature bald eagle, in the style of John James Audubon

Finally, birds began to be viewed as genuine subjects for artistic endeavours and over the next 150 years the number of artists who chose to work in the genre of 'bird art' increased dramatically. The advent of illustrated guides, which gave the reader drawings and paintings of each species to enable clear identification of the birds when out in the field, provided many more opportunities for artists to depict these wonderful subjects.

Up until fairly recent times, almost all art featuring birds was produced in colour and, although most paintings have a line drawing as their foundation, fully rendered and detailed pencil drawings were not very common. Now, however, artists are slowly beginning to appreciate the subtlety and sensitivity that can be achieved in monochrome work, opening up a whole new avenue of exploration for those of us who like to work in pencil, ink or charcoal.

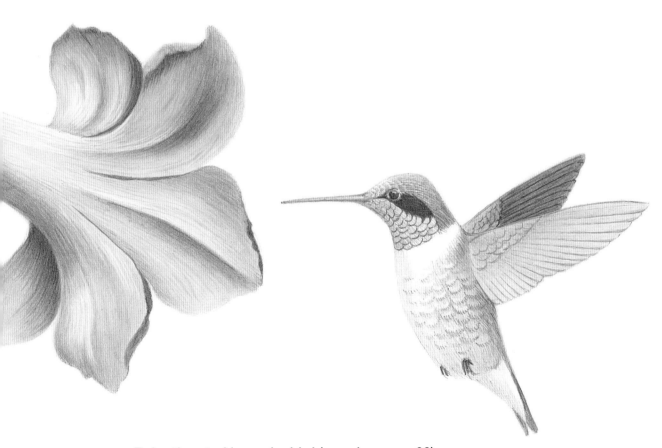

Ruby-throated hummingbird (see also page 39)

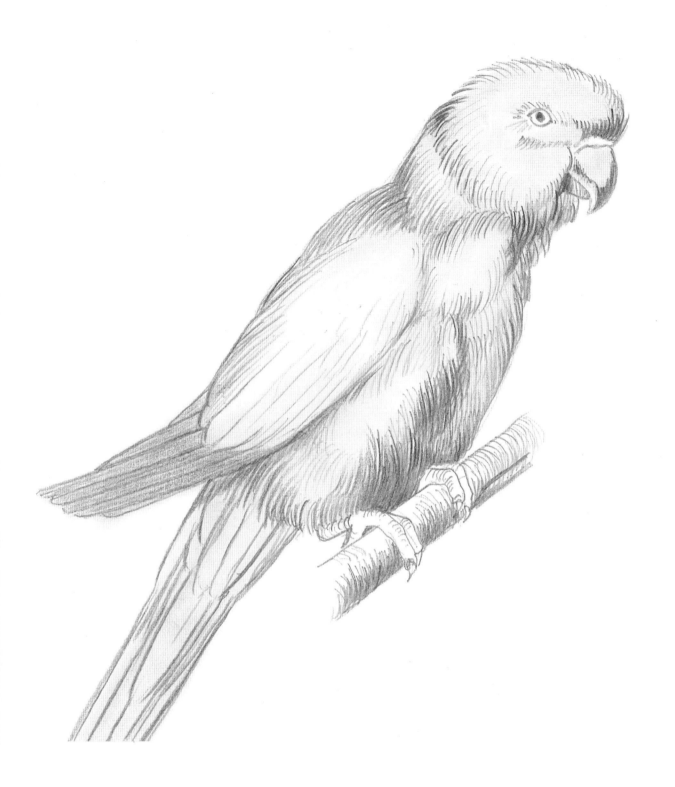

Parrot in the style of Albrecht Dürer

Materials

The huge variety of drawing materials available today can at first glance appear a little overwhelming. With that in mind, in this section I will provide you with a simplified list of the various tools and equipment that I use to create my drawings and explain some of the advantages that each item brings to the process.

As you gain confidence, if you experiment with additional materials, you may find other items that suit your drawing style and help you to achieve your desired results.

GRAPHITE PENCILS

Graphite drawing pencils are produced in a range of twenty grades (of graphite/clay mix). These are 9B, the softest (with the lowest clay content) through F and HB to 9H, the hardest (with the highest clay content). As you would expect, the softest grades deposit the most graphite on the paper, resulting in the darkest lines.

It is always advisable to buy good-quality art equipment. Cheaper pencils are often composed of inferior materials. Wood stems that split, or are not bored accurately to take the graphite, can cause problems when you try to sharpen them. The graphite/clay mix needs to be ground finely to give a smooth, consistent delivery of pigment. Slivers of unground clay in the pencil can scratch the surface of the paper and also result in loss of pencil life, as you have to constantly re-sharpen them to remove offending sections.

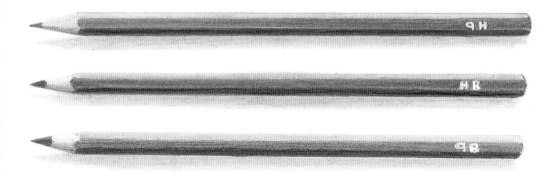

CLUTCH PENCILS

Clutch pencils are another way of drawing with graphite. They comprise a separate 2mm (¹⁄₈in) graphite stick (which is also available in a variety of grades) held within the clutch pencil. These are definitely my preferred pencil and I use the Staedtler Mars 780. They have a lovely balance to them and are very easy to control. You can sharpen them using a lead pointer (see page 16) and they retain their length and balance, unlike traditional pencils, which get shorter and more difficult to hold and control.

WATER-SOLUBLE GRAPHITE AND CHARCOAL PENCILS

These are two more specialized types of pencil that I use occasionally when the need arises. Water-soluble graphite pencils usually come in three different grades: light wash (2B), medium wash (4B) and dark wash (8B).

After application you can add water using a brush or a cotton bud (cotton swab) and this will dissolve the pigment, enabling you to achieve a variety of different effects and textures.

Charcoal pencils also come in a range of three (light, medium and dark) grades and they can be useful if you wish to add some very dark areas of tone in your drawing without creating the 'shiny' effect that a heavy application of graphite can produce.

PENS

Drawing with a pen can give you scope to produce some dramatic images, but the permanent nature of ink means that there is no possibility of removing any unwanted lines in your drawing or blending marks to create gentle graduations of tone.

Another factor to bear in mind is that your paper must be able to accept the ink without any 'bleeding', where the pigment spreads throught the fibes of the surface. The pens below can both be purchased with different widths of nib and the refillable version also gives you the option of changing ink colour when necessary.

Refillable technical pen

Graphic fine line marker

OTHER TOOLS

Tortillon blender

Blenders

These are useful tools for softening and merging your pencil marks where less distinct detail is required in a drawing. They can (once they have picked up some graphite from previous use) also be employed to add some of that pigment back to clean areas of paper, where a delicate pale tone can be created as a base for further drawing.

The texture of each individual blender will impart its own characteristics to the blended area. Paper blenders (known as tortillons, torchons or stumps), brush blenders,

or cotton buds (cotton swabs) create a soft diffuse effect, whereas rubber-tipped colour shapers impart a cleaner, more distinct finish to the blending. You can blend with a variety of tools, but resist the temptation to use your finger, as any grease that is inadvertently transferred to the paper will resist the application of subsequent layers of graphite.

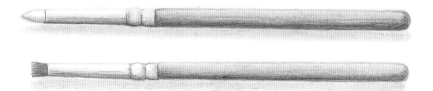

Blenders (from above clockwise): cotton bud (cotton swab), colour shaper and brush blender.

Indenters

These are tools which allow you to intentionally indent your paper surface where you wish to create fine, clean, white detail lines in your drawing (see right). Subsequently, when you work over the paper with a blunt pencil or an impregnated blender, the indentations remain clean and untouched by the pigment.

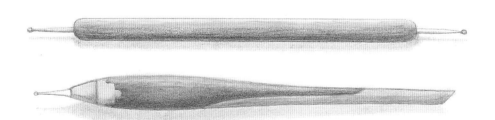

White lines created by first indenting the paper, then working over the top with a pencil and blender.

Erasers

The traditional soft plastic art eraser is always useful, especially during the preparatory drawing stage, but the two erasers that I find most helpful are the stick eraser and a large piece of adhesive mounting putty.

The pencil-like stick eraser can be trimmed and shaped to give a fine chisel edge to the tip, allowing fine lines of graphite to be removed from your drawing where necessary (see illustration below).

The mounting putty can be moulded into a variety of shapes much more succesfully than a putty eraser and has an adhesive quality that will allow you to gently lift away graphite to create highlights in a drawing, or just to clean your paper of unwanted marks.

Adhesive mounting putty

Stick eraser

White lines created by applying graphite with a pencil and blender, before drawing the 'chisel edge' of a stick eraser across the paper.

Sharpeners

You can use a sharp craft knife or a traditional sharpener to put a fresh point on your wood-cased pencils, but my preferred piece of equipment is an electric sharpener, which creates a much longer point on the pencil.

 If you use clutch pencils then you will also need a lead pointer to sharpen the graphite core of the pencil. These tools create a wonderful fine point on the graphite and also collect a reservoir of powder that can be reapplied to areas of your drawing (using a tortillon blender or a watercolour brush), to create further interesting textures.

Electric sharpener

Craft knife

Traditional sharpener

Lead pointer

Scale dividers

These are a very useful tool to help with the process of transferring acurate proportions from your drawing or reference photo. By varying the position of the central pivot, you can create varying proportional differences between the tips at either end of the dividers. These proportions then allow you to enlarge or reduce the dimensions that you apply to your finished drawing.

PAPER

For detailed work in pencil I always prefer to work on either Hot Pressed watercolour paper (smooth) of at least 300gsm (140lb) weight, or on Bristol board, which is an ultra-smooth, thick paper that will also accept the application of ink if necessary (see the tonal illustration, right).

On occasion, if I require more texture in my finished drawing then I may use a NOT surface watercolour paper of a similar weight. This is a paper that has an intermediate texture; it is rough enough for you to incorporate the surface texture into your drawing, but not so rough that it inhibits the creation of detail (see tonal illustration, below right).

Another aspect to consider is that if you plan to indent the surface to create detail in your drawing, then it is a good idea to use a thick paper. This will enable you to produce deeper indentations, which will remain clean and clearly defined after graphite has been added.

Two other papers that I use during the drawing process are cartridge and tracing paper. All my images are first drawn on cartridge paper (where I can make as many adjustments as I require) and then transferred, using tracing paper, to my finished surface.

An even covering of graphite applied using an impregnated blender on smooth Bristol board.

Interesting texture created by applying graphite from an impregnated blender on Bockingford watercolour paper.

How to start

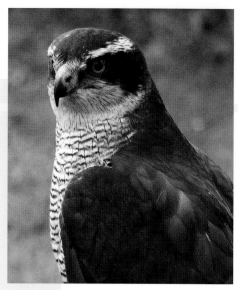

Goshawk reference photograph

PREPARING YOUR WORKSTATION

For small drawings – less than 61cm (24in) dimensions – I like to work on an adjustable table top easel. This allows me to create the most comfortable position for drawing, with the top of my drawing board raised off the desk at an angle. As I am right-handed, I place all my equipment to my right-hand side on the desk. My pencils, erasers, dividers and so on are kept in a kitchen cutlery tray, which has separate partitioned sections, so I know exactly where to find things as I need them.

Good lighting is essential, so you will often need to supplement the ambient light in your room with extra illumination. A simple clip-on lamp will suffice, but it is worth making sure that it can be fitted with a daylight bulb or tube in case you decide to work in colour. Ordinary household bulbs give off a yellow light, which can make it difficult to match colours correctly.

Reference material

Having plenty of reference material is vital if you are to create accurate and realistic drawings. For composition ideas, this can take the form of your own sketches and photographs. Quick drawings that are noted down in a sketchbook may not always be very detailed, but they can generate ideas for interesting pictures, while supporting photos can provide the extra information that you may not have time to record in your sketch.

When you begin working on a drawing at home, you can supplement the information that you have gathered with photographs that you find in books and magazines. However, at this point I would issue a warning regarding the use of other people's photographic and artistic material. You will be infringing copyright law if you copy another person's images without permission. So always make sure that your composition ideas originate from your own photographs or drawings and use other photographic reference purely for information on plumage detail and so on.

When collecting my own photographic reference, I use a Panasonic Lumix FZ200. This is what is commonly known as a 'bridge camera' – something between a point-and-shoot camera and a full-blown digital SLR camera. It is a little larger than the compact digital models that are available, but not as large and cumbersome as many of the digital SLR cameras. It is easy to carry with me wherever I go and it has a high quality 25–600mm (1–24in) zoom lens for getting close-up reference shots.

SKETCHING

Drawing birds from life gives us the opportunity to closely observe our subjects and to learn more about how they move and behave. The more we are familiar with the subject that we choose to draw, the more accurate the resulting drawing will be.

So a small sketchbook and pencil kept in your bag or coat pocket can be utilized to quickly jot down a few important details of anything inspirational that you encounter. Don't worry too much about the 'finish' of these drawings. They are not meant to be masterpieces, merely informative marks and annotations that might later provide some details (of plumage, pose, behaviour etc.) that you can make use of in future, more detailed, drawings.

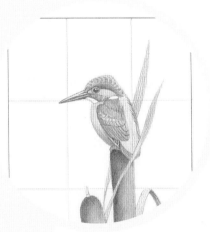

Starting your drawing

For every drawing or painting that I work on, I begin by creating a 'layout' drawing on a sheet of cartridge paper. Here I can make as many changes to the proportions and details of my subject as I need, without having to be concerned about any damage that I may be causing to the surface of the paper. If you begin by drawing directly onto your watercolour paper and you find that you need to make changes, you will be able to remove the graphite marks, but you will be left with indentations where those unwanted lines had been drawn. These will be very difficult to work over successfully later in the drawing process.

These initial drawings can have as much (or as little) detail as you feel you need. Some may just be simple outlines with detail of some of the important features such as the eyes, feet and so on included; while others may need to be much more detailed, giving extra consideration to the feather patterns and shapes.

For all of us there is a huge temptation to dive straight into the final drawing. However, a little extra time spent on your initial preparation can save you time in the long run. You can draw with confidence, knowing that you are much less likely to encounter problems or mistakes that might result in you having to start all over again.

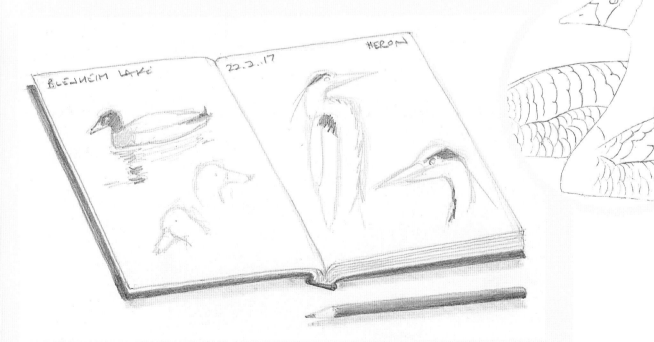

TRANSFERRING YOUR IMAGE TO PAPER

Once you have successfully completed your layout drawing, you will need to transfer it to your final drawing surface and for this I use tracing paper.

There are a number of advantages to this tracing system. After each new drawing you will be left with a tracing that you might be able to incorporate into a future drawing or painting, saving you the time that would be involved in redrawing the subject.

If you are including a number of subjects in a composition, draw and trace them all separately. Then you can lay out your tracings and move them around to experiment with many different compositions and combinations in a fraction of the time it would take you to draw them.

You will need:

A sheet of tracing paper (large enough to cover the whole of your rough drawing)
HB, 6B and 4H pencils
A solid surface to work on

1 Lay a clean sheet of tracing paper over your layout drawing and carefully trace all the important lines using an HB pencil, making sure that you create clean, clear lines.

2 Turn your tracing paper over and lay it on a clean piece of paper so that you can clearly see the outline that you have drawn. Retrace the outline using a soft (5B or 6B) pencil.

3 Now turn your tracing paper back over and lay it onto your final paper surface in the position that you require. You now have the 6B outline against the paper and, using a hard pencil (2H or harder), you trace the outline one final time. The soft graphite will transfer to your clean paper without the need to press too hard and you will create a clean outline to begin your drawing.

Tip

During step 3, if your tracing is quite detailed it might help to secure it to your paper with a small piece of 'low-tack' tape. This will help to prevent the tracing from slipping to a new position during the transfer stage, but will be easy to remove without damaging the paper when you have finished.

COMPOSING YOUR PICTURE

In order to create a successful drawing, it is important to appreciate that there is more to consider than just physical accuracy. The positioning of your bird subject within the rectangle of the paper and its relationship to the background that you select are also aspects that you should consider carefully.

Always try to avoid placing your subject directly in the centre of your composition. You can achieve a more interesting arrangement if you imagine your picture space divided into nine equal portions by two evenly spaced horizontal lines and two evenly spaced vertical lines. Placing your main subject on or near one of the intersections created by these lines will create a stronger composition.

Also, even if you plan to have a fairly simple composition with very little surrounding detail, you can still help to suggest that your bird is an integral part of the scene that you are depicting, by allowing elements of the habitat to overlap the bird. This helps to avoid the 'cutout' effect that can often give the impression that the bird was added as an afterthought.

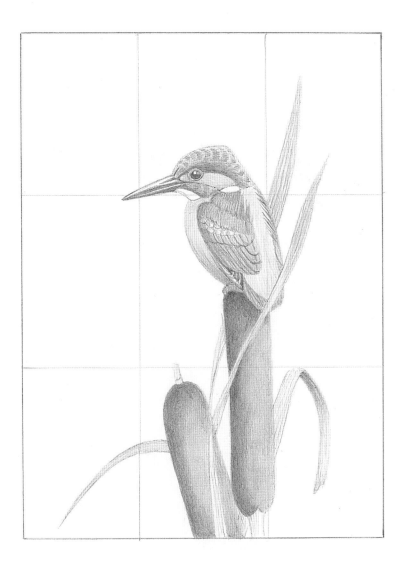

Building detail, shape and form

Having successfully transferred your outline, you are now ready to begin the process of bringing your drawing to life, by adding the detail, highlights and shadows.

As we are working with a dry medium, we cannot apply washes or glazes to create areas of even tone, so a little time spent developing a controlled drawing technique will prove invaluable.

For my bird subjects I always apply the graphite by drawing in just one direction (picture 1). If you move the pencil back and forth across the paper (picture 2) you run the risk of creating distracting lines where you have doubled back with your pencil. This may seem like a difficult technique to master to begin with, but with practice you will be able to produce a beautiful even layer of graphite, which can also be blended further to increase the uniformity of tone, or to soften the lines where you require less detail.

Picture 1

Picture 2

Picture 3

For any background elements in your drawing (such as dead leaves, bark, rocks and so on) that require a more textural finish, you can employ a circular application technique (picture 3). This will allow you to build up tone with an irregular pattern of marks that mimics the texture that you are trying to depict.

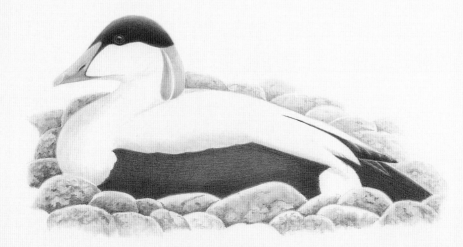

One important consideration as you begin to build up the detail in your bird drawing is in which direction your pencil lines should be applied.

When drawing birds, I always begin at the beak and work back towards the tail. This means that all my lines follow the line of the feather growth and the form of the bird's body, while also helping to develop the detail that I require in the finished drawing. As I add subsequent layers, I can increase the depth of tone in some areas by using a softer grade pencil to start to give some form to my subject.

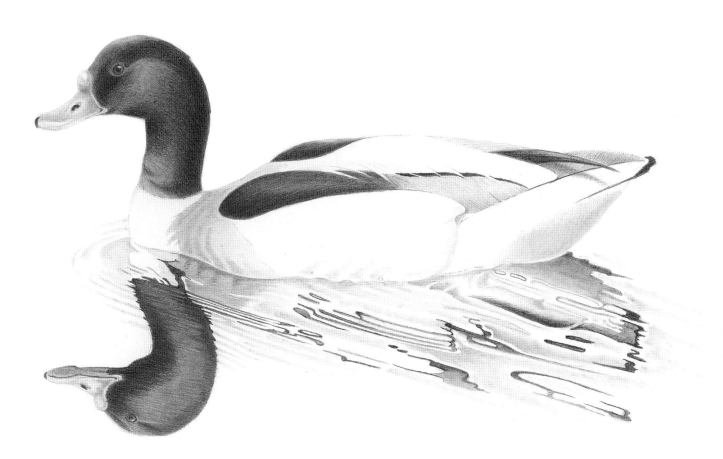

Shelduck

Bird features

This chapter is divided into sections that focus on the important features of birds and highlight the marked variations that can occur in these characteristics from one species to another.

WINGS

The wings of a bird are essentially its front legs, but they are no longer used to maintain its weight when standing. The strong but light bones of these limbs provide attachment for the flight feathers and articulate with each other to allow the wing to be held out during flight, or folded in close to the body when the bird is at rest.

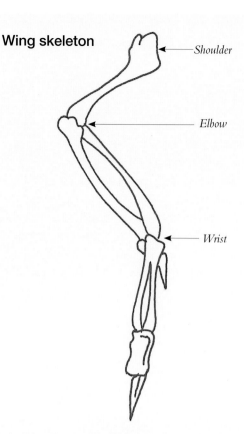

Wing skeleton

Shoulder

Elbow

Wrist

A feathered wing

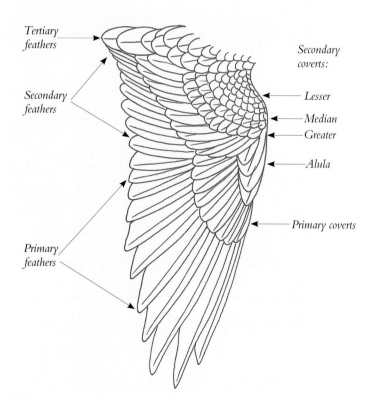

Tertiary feathers

Secondary feathers

Primary feathers

Secondary coverts:

Lesser

Median

Greater

Alula

Primary coverts

Just like the arms in the human skeleton, the wing is composed of the same bones: humerus (upper arm), radius and ulna (forearm) and carpals, metacarpals and phalanges (wrist, hand and fingers). In birds, the number of fingers has reduced during their evolution from the original five to just three.

However, the size of these bones can vary dramatically between species. The size and shape of a bird's wing is dictated by the habitat in which it lives and by its need for speed, manoeuvrability, or a combination of both. As a result the size, shape and number of each type of feather will also differ from one species to another. See the sections on Feathers (page 26) and Birds in flight (page 34).

As can be seen in the illustration of the feathered wing (see left), the feathers overlap one another to create a continuous, smooth and flexible surface, which provides thrust as the bird flaps its wings. The upper surface of the wing is curved, so as the bird moves forward in the air, this creates a differential in the air speed/pressure above and below the wing, resulting in lift.

Study of a bird's wing

In this drawing I have chosen to illustrate a fieldfare's wing to show the arrangement of the feathers when the wing is folded against the body.

Stage 1

Having traced and transferred my drawing, I have begun to fill in the upper wing feathers using an HB pencil. As described on page 23, all my marks are applied in a 'beak to tail' direction, so that any marks that are still evident after blending later will help to create a more realistic finish to the drawing. I have purposely left a narrow white border around each feather.

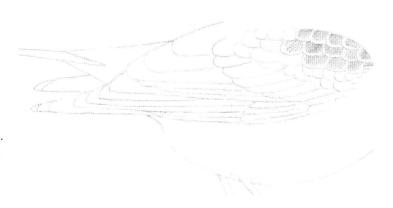

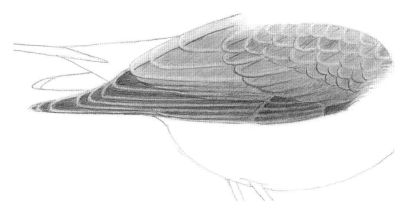

Stage 2

Now, with all the upper wing and secondary feathers filled in, I have begun to block in the darker primaries using a 5B pencil. Once again, I am taking care to leave a white border around each feather.

Stage 3

Having completed the initial layer of graphite on the primaries, I have now carefully blended the whole feather area (head to tail) using a tortillon. This has dragged a pale graphite tone over the white feather edges and softened the overall effect.

I then used my mounting putty to lift off some graphite to create highlights on the top edge of the wing and increased the depth of tone on the lower edge with a 5B pencil.

All that remained was to add some of the dark central feather veins and to introduce dark shadow lines around a few feathers using the 5B pencil once again.

FEATHERS

The basic structure of a feather comprises a central, fairly rigid spine, called the rachis. Along the two opposite edges of this runs a line of filaments called barbs. These have minute hooks along their length, which allows each filament to link with adjacent barbs to create a flexible surface.

A bird's feathers fall into three main types: flight, tail and body feathers. Flight (wing) feathers are strong and flexible. As mentioned in the Wings section, they vary in size and shape between species, depending on the flight characteristics of the bird.

To the right you can see a scale drawing to compare the variation in size and shape of a golden eagle primary feather with the corresponding flight feather from a house sparrow.

Primary flight feather

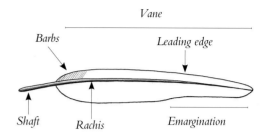

Comparison of a golden eagle primary feather and the corresponding feather from a house sparrow

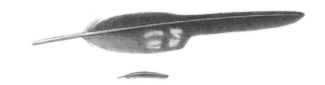

Tail feathers, which are similar in structure to the flight feathers, can also vary dramatically in size and shape. They do have a role to play in flight, sometimes providing an effective 'rudder', which the bird can employ when changing direction, or as an 'air brake' when they are spread wide upon landing. They are often also used during courtship displays.

Below you can see a selection of tail feathers (not to scale), which show some of the variations in shape that can occur.

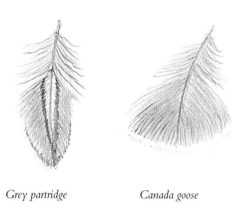

Grey partridge Canada goose

Body (contour) feathers are usually smaller and less distinct in their shape. The filaments are softer, creating a smooth outline to the bird's body to provide an aerodynamic shape, while the downy filaments that are found toward the base of the feather afford a high level of insulation. Above, you can see a couple of examples of these delicate feathers.

In the Birds in flight section (see page 34), I will show several examples of species variation, where the feathers vary depending upon the flying and hunting habits of each bird.

Examples of different tail feather shapes (not to scale)

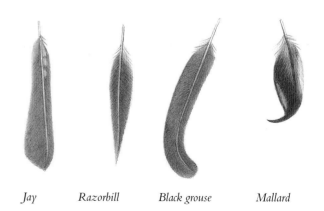

Jay Razorbill Black grouse Mallard

Study of a bird's feather

The basic structure of a feather is fairly simple, but for this example I have chosen the flight feather of a woodcock, which also has an interesting pattern to depict.

Stage 1

Having traced and transferred my simple outline, I first added an even tone of graphite by rubbing a tortillon blender on to a 9B (very soft) pencil and then used the blender to gently apply the graphite to my drawing. When the initial layer was complete I began to depict the barbs using an HB pencil, making sure that my pencil lines followed the direction and angle of these structures.

Stage 2

When the initial barbs were all in place I began to add some of the pattern detail using a 5B pencil to give a darker tone.

I also used the same pencil to draw a dark shadow line along the bottom edge of the central shaft of the feather.

Stage 3

In this final stage I completed the pattern detail and then used my tortillon to gently blend over the whole feather to soften the finished effect.

Once again, I reinforced the shadow line along the centre of the feather with my 5B pencil and then, to finish the study, I used my stick eraser to carefully remove the initial outline.

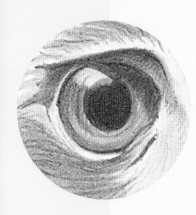

EYES

When drawing a portrait of any living creature, the eyes are one of the most important aspects to consider. However, the eyes of many birds are fairly small and so it is vital that we observe our subject carefully and make sure that we record these important characteristics accurately.

The eyes of birds are much like those of humans, in as much as they possess a coloured iris and a round, black pupil. The colour of the iris is perhaps the most important factor to consider and there are numerous variations across all the bird species.

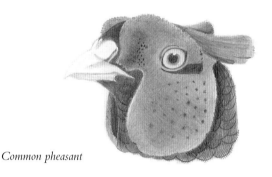

Common pheasant

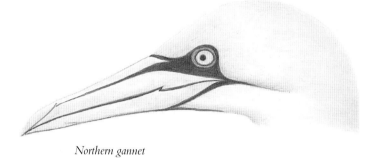

Northern gannet

In the two drawings above, you can see examples of species that have very pale iris coloration. The actual colour of the common pheasant's iris is a golden yellow, while that of the northern gannet is a pale cream, but in both birds the contrast between iris and pupil gives the bird a characteristic stern expression.

In the case of the common ringed plover and the peregrine falcon, the iris coloration is very dark, giving the appearance that the eye is actually completely black. However, as some plovers and also some other birds of prey have paler eye coloration, make sure you check your reference to ensure that you create an accurate drawing.

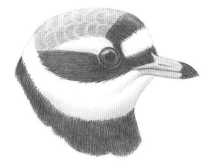

Common ringed plover

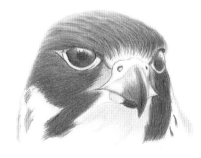

Peregrine falcon

In this study of the eye of an eagle owl, I have focused on the variation in the colour of the iris and also on creating the important curved highlight.

Stage 1

Having transferred my drawing I created the dark eye ring and pupil using my 2B pencil. You will see that I left a curved triangular space across the pupil, which is where the highlight will be placed.

I also used my 2B pencil to begin to draw in the 'tear' patch beneath the eye.

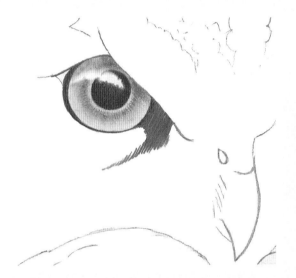

Stage 2

I began this stage by rubbing a soft (5B or 6B) pencil onto the tip of my tortillon blender and then used the blender to add a soft mid-tone grey on the area of the owl's iris, making sure that I left the highlight area clean.

Then, using my 2H pencil, I worked around the pupil, adding a ring of short lines that radiate out towards the outer edge of the eye.

Stage 3

In the final stage, I used my tortillon once again to add a little tone to the highlight in the dark pupil area. It is important to appreciate that the highlight will vary in intensity as it falls across the eye, because the eye's surface is convex. So the overall shape of this highlight should, where possible, be curved to indicate this important fact.

However, as previously mentioned, many birds have extremely small eyes, so there may not always be enough space to include a curved highlight, even if you are drawing the bird life size.

Finally, I put in some of the feather detail around the eye using my 2B pencil for the dark areas (including the beak), a 2H pencil for the fine lines and the tortillon to add the grey base tone.

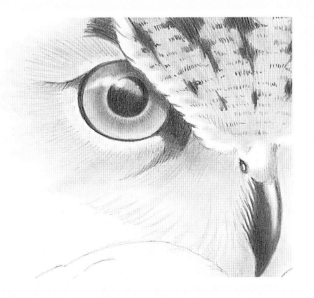

BEAKS AND BILLS

One of the most distinctive features of any bird is its bill (or beak), a horny projection on the front of the skull. The shape and size of birds' beaks can differ widely between species, dependant upon the type of food that each bird consumes. So whether your subject is a small, insect-eating species, or a powerful bird of prey, it is vital that you understand the lifestyle of the bird and depict its bill correctly.

The following five drawings show a small selection of bill types, with reference to each species' diet.

Grey heron

The dagger-like bill of the heron is typical of a water bird that catches fish and frogs in shallow water.

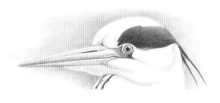

Golden eagle

After successfully catching its prey, this bird's powerful beak is used to tear portions of meat from the carcases.

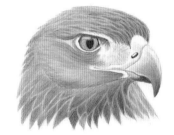

Atlantic puffin

This most distinctive bill is used to collect sand eels as the bird swims underwater.

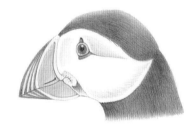

Eurasian wren

As this bird feeds on tiny insects and spiders, it needs a slim beak to probe the cracks and crevices where these creatures hide.

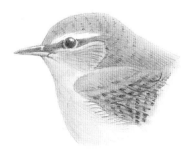

Eurasian woodcock

In order to find the worms that this bird feeds upon, the woodcock requires a long sensitive bill to probe deep into soft earth.

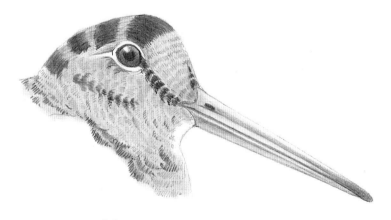

Study of a bird's bill

This is a drawing of the bill of a whooper swan. Its hard, smooth surface is created by applying an even layer of graphite and with the addition of shape-defining highlights.

Stage 1

First, I transferred my outline and began by applying a layer of tone in the black area of the bill and also the eye, using an HB pencil.

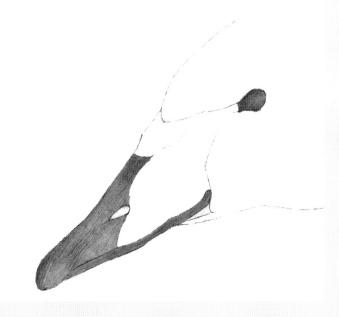

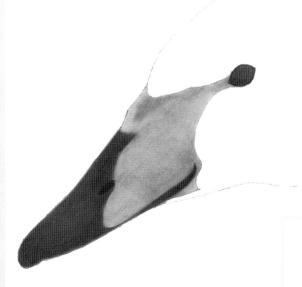

Stage 2

Using a 2B pencil for the dark areas of the bill, I then began to build up the level of tone, blending with my tortillon to achieve an even covering. Then, using the same blender, I rubbed over the clean area of the bill to add a lighter tone. This helps to differentiate this yellow area from the white plumage of the swan's head.

Stage 3

In the final stage, I used my stick eraser and mounting putty to lift graphite from the drawing to create the highlights that give form to the bill and to lighten the 'yellow' area. I also used my 2B pencil to darken the shadow area along the base and side of the bill.

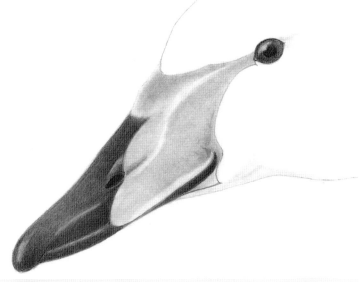

FEET

Just as with birds' beaks, their feet can vary significantly between species and the main factor affecting these variations is the environment in which the bird lives. In the following drawings, I have shown a few different examples of birds' feet with reference to the particular bird's habitat.

Common redshank

This long-legged wader spends most of its time at low tide searching for food on mudflats, where its long, widely spaced toes help to prevent it from sinking into the soft ground.

Great spotted woodpecker

Woodpeckers are arboreal species and in order to be able to grip the bark of trees as they move around, their feet are arranged with two backward-facing toes, instead of the usual one that is found in most other species.

Mallard

To create the thrust required to propel their bodies across the water surface of rivers and ponds, the mallard, in common with all other duck species, has webs between its three forward-facing toes.

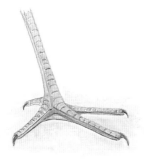

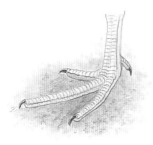

Grey partridge

As with most game birds, the grey partridge spends most of its time on the ground and will often run to evade predators. To facilitate this method of movement, it has strong forward-facing toes and a reduced hind toe.

Song thrush

The thin, delicate toes of the thrush provide a stable platform for the bird when it is standing on the ground, but are flexible enough to firmly grip a twig or branch when it is perched in a tree.

Barn owl

The barn owl has the standard three forward-facing toes, with one hind toe. However, the outer toe on each foot has a flexible joint and it can be turned back to provide added grip on irregular-shaped surfaces.

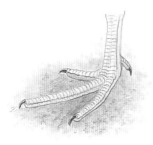

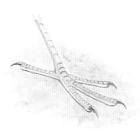

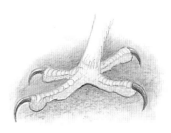

Study of a bird's foot

For this example I have chosen to show the foot of a golden eagle. The rough, scaly skin and the hard, glossy talons are important distinguishing features.

Stage 1

In this first stage, I transferred my drawing to the watercolour paper and used a 2B pencil to lay down the black tone on the claws, making sure to leave an area of highlight untouched. Then I used a torchon to blend the dark graphite and create an even covering of pigment. Along the edge of the dark tone I used the blender to soften the edge of the highlight.

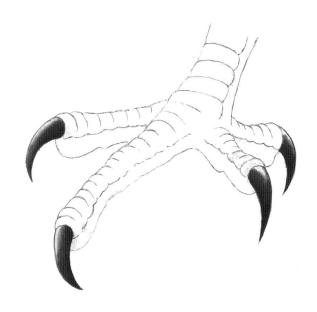

Stage 2

With the same (heavily impregnated) blender and, using it like a pencil, I then began to build the texture and form of the foot, adding dark marks to delineate the ridges and scales.

Stage 3

To finish the drawing, I completed the texture across the whole of the foot in the same way as in stage 2. When my blender marks began to get lighter, I rubbed the torchon on a 9B pencil to boost the amount of graphite that I was adding to the drawing.

I also built up the tones in the shadow areas of the drawing and used my mounting putty to lift out some highlights and texture.

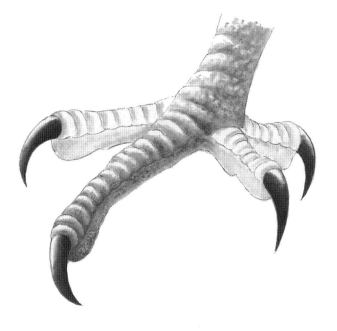

Birds in flight

True flight is an ability that is displayed by only three groups of creatures: birds, bats and insects. There are others, such as some squirrels, fish and reptiles that can glide for short distances with the aid of extra flaps of skin, enlarged pectoral fins or large webs between their toes, but they can only travel in a straight line and gravity soon overcomes these brief airborne excursions.

In order for birds to overcome the effects of gravity, their skeletal structure has evolved with a number of changes from their original land-based reptilian ancestors. Their skeleton now has fewer bones and the ones that remain are much lighter by virtue of the fact that they are actually hollow, strengthened with an internal honeycomb of struts.

For any land-dwelling animal, the weight of its skeleton is not so important, because it can develop larger muscles to enable it to move around, but there are weight limits that are imposed upon birds. The heavier the skeleton, the more muscles are required for movement and, of course, this adds to the bird's overall weight. So eventually there is a point at which a bird's size and weight makes it physically impossible for it to take to the air.

The one factor that makes birds the most successful of fliers is the design of their wings, as described in the section on wings (see pages 24 and 25). The structure is basically the same from one species to another, but variations in the wing size and shape occur, which are dictated by each bird's lifestyle.

It is important to be aware of these variations when you are drawing, because the wing conformation will affect a bird's shape even when it is not flying. On the following pages you will see a selection of five different bird species with varied wing proportions.

BLACK-BROWED ALBATROSS

All birds of the Diomedeidae family are seabirds, which spend many days covering hundreds of miles out at sea. They have very long wings and a typically undulating style of flight as they glide low over the water, making use of powerful air currents that are created by the movement of the waves. Using the moving air to best advantage, the albatross is able to keep its energy expenditure to an absolute minimum, only rarely needing to actually flap its wings.

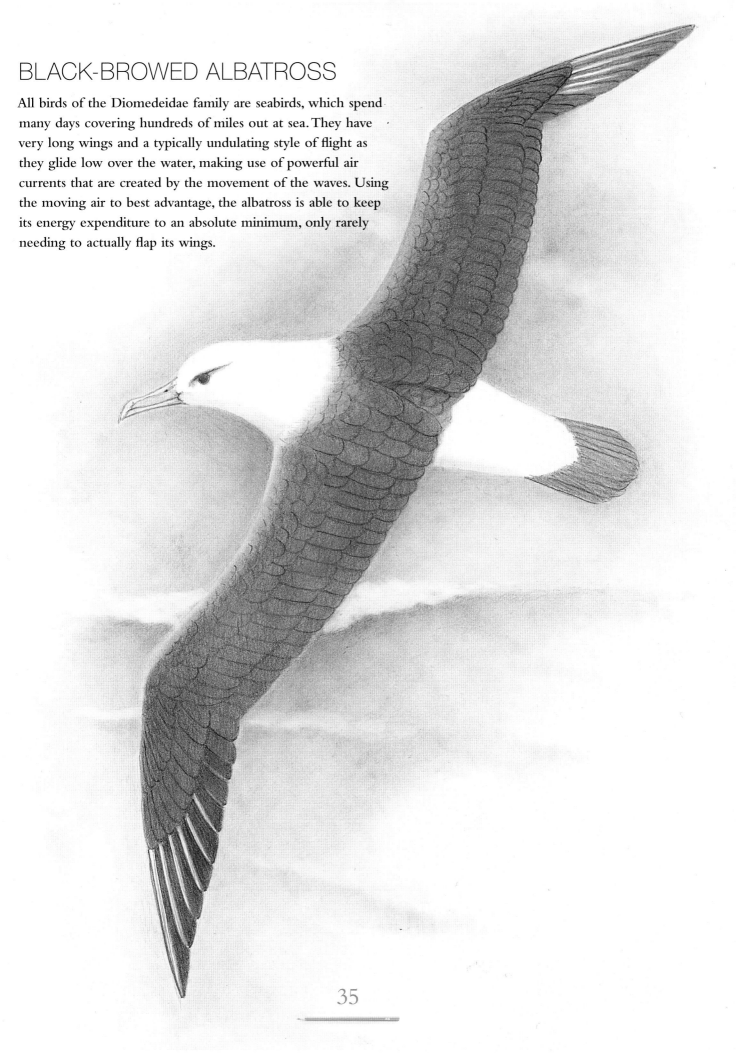

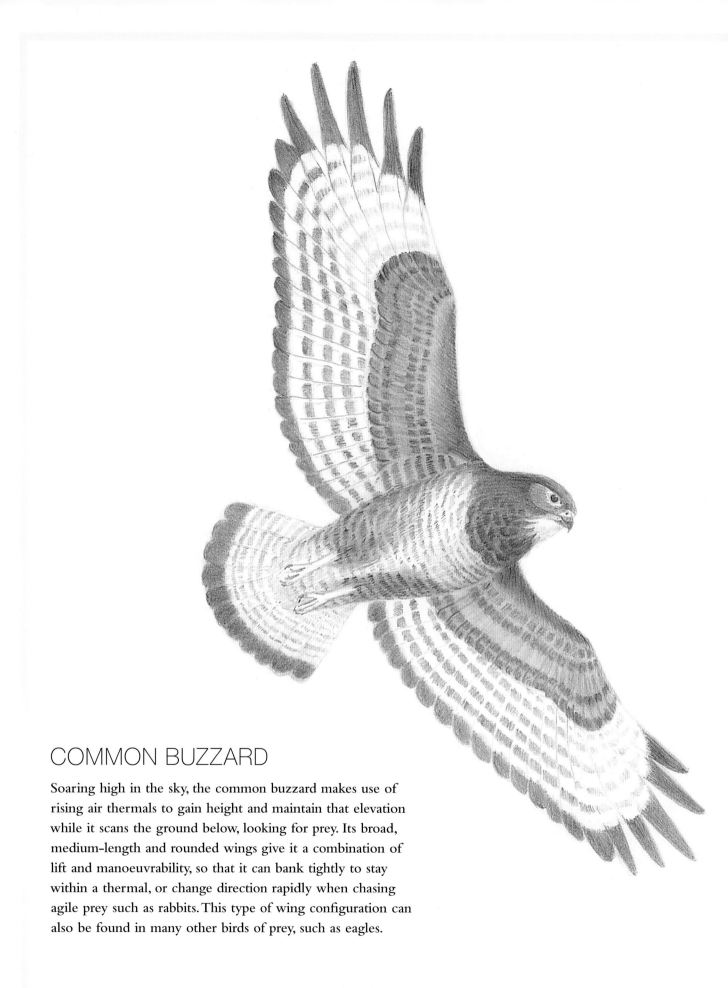

COMMON BUZZARD

Soaring high in the sky, the common buzzard makes use of
rising air thermals to gain height and maintain that elevation
while it scans the ground below, looking for prey. Its broad,
medium-length and rounded wings give it a combination of
lift and manoeuvrability, so that it can bank tightly to stay
within a thermal, or change direction rapidly when chasing
agile prey such as rabbits. This type of wing configuration can
also be found in many other birds of prey, such as eagles.

EURASIAN JAY

Here is another species with the rounded wings necessary for agile flight. However, being a woodland bird, it occupies a habitat where the ability to evade obstacles such as tree branches is essential, so by necessity its wings are shorter than the high-flying eagles and buzzards. This reduced size does, however, mean that these birds have to flap their wings more to maintain elevation. This type of wing is common to numerous species, including many of our smaller garden birds, which were once primarily woodland birds themselves.

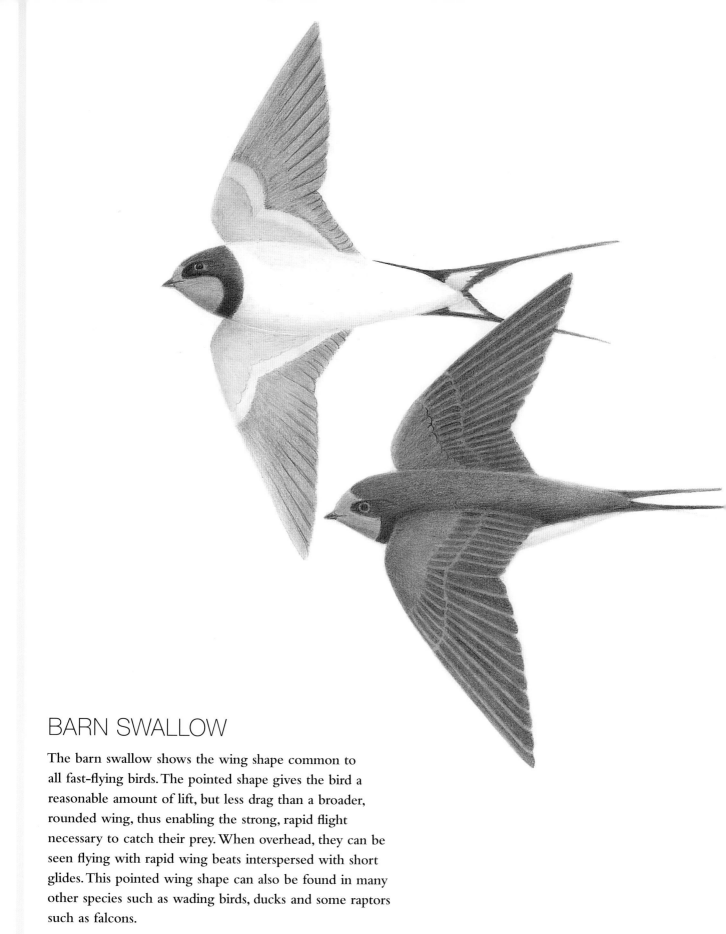

BARN SWALLOW

The barn swallow shows the wing shape common to all fast-flying birds. The pointed shape gives the bird a reasonable amount of lift, but less drag than a broader, rounded wing, thus enabling the strong, rapid flight necessary to catch their prey. When overhead, they can be seen flying with rapid wing beats interspersed with short glides. This pointed wing shape can also be found in many other species such as wading birds, ducks and some raptors such as falcons.

RUBY-THROATED HUMMINGBIRD

Hummingbirds are unique among all bird species in their ability to hover and also to fly backwards. They have much greater articulation in their shoulder joints, which allows the wing to create lift on both the upstroke and the downstroke.

This adaptation, coupled with a wing speed of up to 80 beats per second, allows hummingbirds to maintain absolute control over their flight and enables them to hold their airborne position close to a flower to gently feed on the nectar.

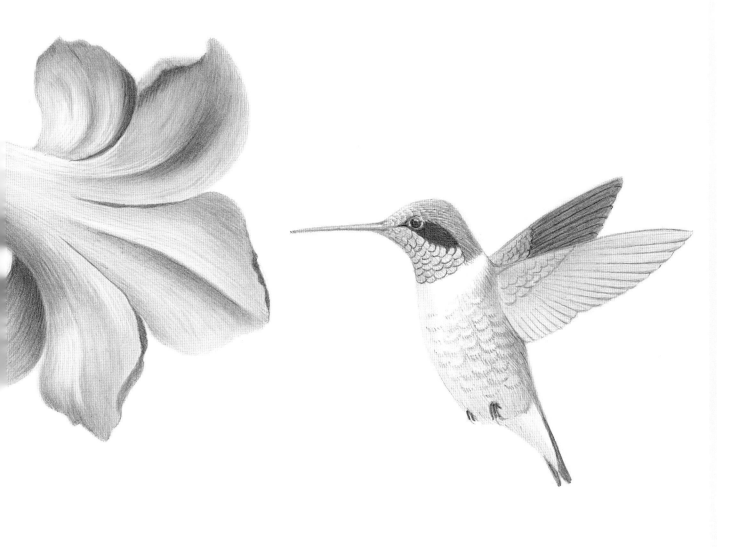

Bird groups

This section features seven different groups of birds and for each of them I have included some examples of the variety that can be found within the group, along with a step-by-step drawing demonstration of one particular species.

WADERS AND WATER BIRDS

This section features the birds that tend to live on or near water, that do not fall within the wildfowl or seabird groups. It is probably the most diverse group and includes birds from numerous different families, whose appearance, lifestyle and feeding techniques vary dramatically. Here are three varied examples from this group.

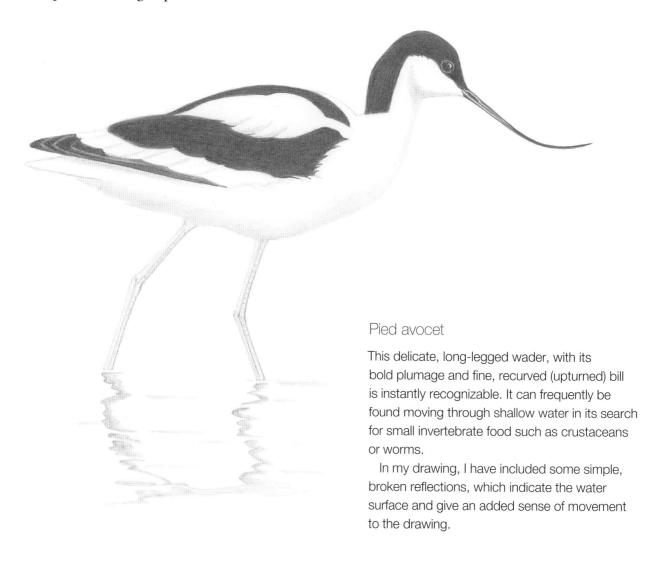

Pied avocet

This delicate, long-legged wader, with its bold plumage and fine, recurved (upturned) bill is instantly recognizable. It can frequently be found moving through shallow water in its search for small invertebrate food such as crustaceans or worms.

In my drawing, I have included some simple, broken reflections, which indicate the water surface and give an added sense of movement to the drawing.

White-throated dipper

Fast-flowing, shallow, rock-strewn streams are the preferred habitat of this diminutive bird, where it hunts for its aquatic insect food.

Dippers are unique among passerines (perching birds) in their ability to dive and swim underwater. To enable them to achieve this, they have relatively short but strong wings, which they use as flippers to 'fly' underwater. The short bill is employed to turn over small stones and pebbles on the river bed to disturb and locate its prey.

Black-throated loon (diver)

This species lives on open water and feeds on fish that it catches by diving below the surface, sometimes to depths of up to 4.5 metres (15 feet).

Its unique, boldly patterned plumage presents a challenge to the artist, but when depicted accurately the combination of stripes, spots and geometric shapes can help to clearly define the form of the bird.

Common moorhen

This species presents us with two distinct challenges; first, creating a sense of form by the use of highlights on the dark plumage and second, achieving the correct proportions between the bird's body and its oversized feet.

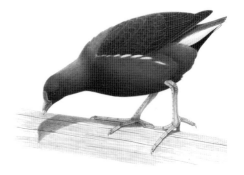

1 **Outline** Transfer your outline to the Bristol board, either by producing your own version of the drawing on a separate sheet of paper and tracing it, or by tracing the outline from this page. Refer to the tracing method on page 20 if you are unsure about how to proceed. Once you have transferred your drawing it is a good idea to then redefine all the lines of your outline using light pressure and a sharp 2B pencil. Do not press too hard, as you do not want to create indentations in your paper surface that might show later as you try to apply detail over them. As graphite can smudge easily it is a good idea to make sure that you have a second sheet of paper, which you lay across the drawing to rest your hand on while you work.

MATERIALS

250gsm (115lb) Bristol board
2H, 2B, 5B and 9B pencils
Blending stump
Mounting putty
Stick eraser

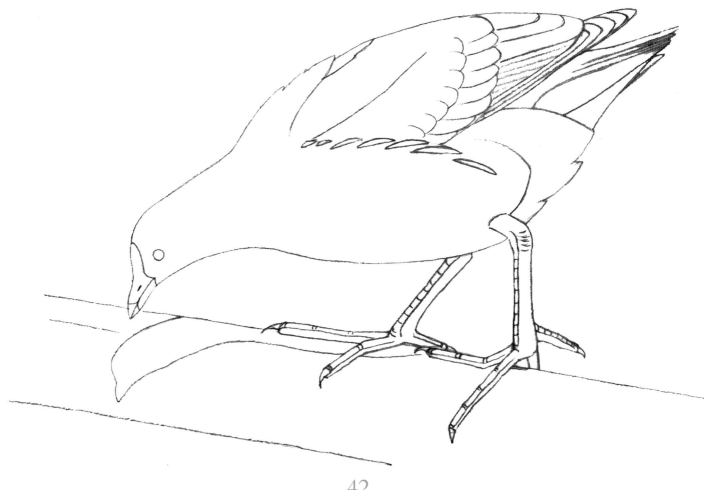

2 **Bill** Begin by laying in an even tone of graphite on the bill and face shield using a 2H pencil, leaving a small section at the tip of the bill untouched. Then, continuing with the same pencil, apply another layer of graphite to create the darker areas that give the bill its shape. Use a 2B pencil to add the nostril and also the shadow line along the edge of the upper mandible.

Eye Moving on to the bird's eye, use your 2B pencil to draw the outline and to add the dark pupil in the centre, leaving a small white highlight. Once you have done this, use your stump to gently blend across the eye (avoiding the highlight). This will drag some of that soft graphite across the iris area and give it an intermediate tone.

Head Still using your 2B pencil, begin to apply an even layer of graphite with parallel lines that follow the shape of the bird's body, working from bill to tail. At intervals, you can gently blend these lines to help create a soft feather-like effect, making sure that you follow the same lines with your blender as you did with your pencil. Where there are areas that are in shadow, repeat the layers of graphite to gradually build darker tones.

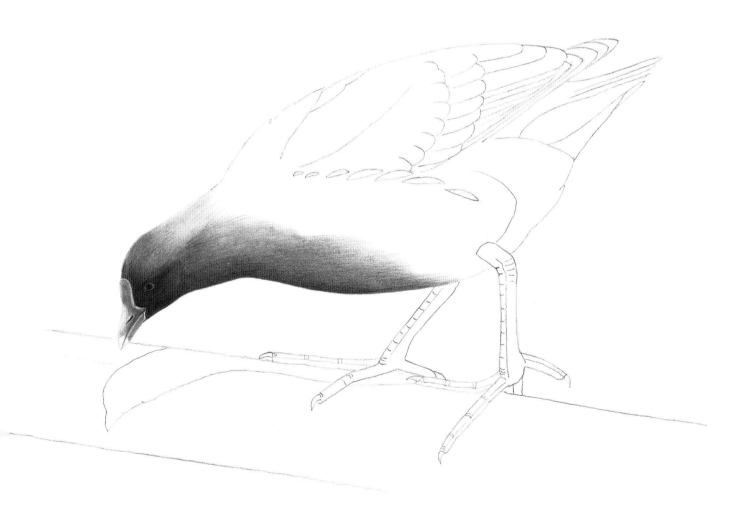

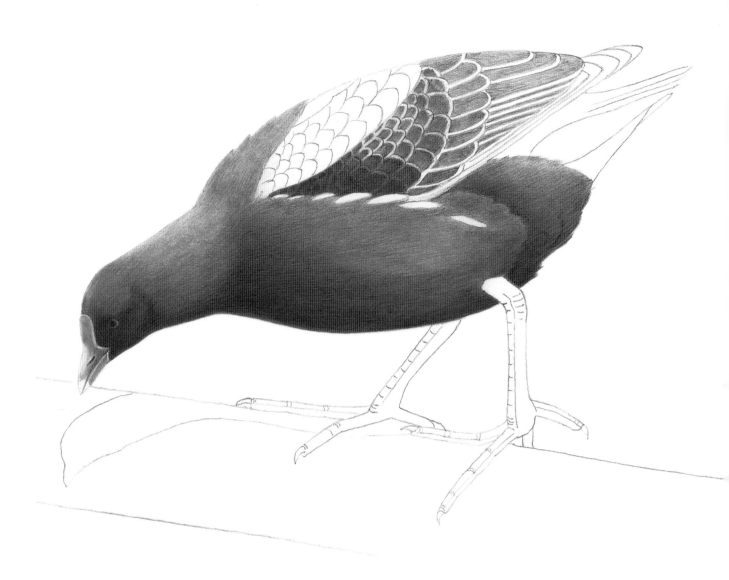

3 **Body** Continue adding graphite to the rest of the nape, breast and underside of the bird, taking care to leave the white flashes along the moorhen's flank. Where there are areas of shadow, increase the tone slowly until you reach the required level.

Shoulder and wing The feathers on these sections of the bird's plumage are much more individually distinct, so draw in their outlines and then begin to 'fill in' each one using medium pressure and your 2B pencil. Take care to leave an untouched border around each of these feathers. When the feathers are all filled in, then use your 2B pencil with firm pressure and lay another layer over the whole area (including the pale feather borders). Apply the graphite in the same head-to-tail direction as with the body and this will darken the whole area, but still allow you to see the paler feather edges. When this is completed, use your stump to blend the graphite and soften the overall effect.

4 **Shoulder and wing** Finish the whole of the wing section as described in step 3 and then use your 5B pencil to add some dark shadow lines along the edges of the primary and secondary feathers.

Tail Using the same technique as for the body, apply graphite to the upper tail feathers with your 2B pencil. Build the level of tone along the area beneath the primary feathers to create a shadow and add fine shadow lines between the tail feathers as you did with the wing. For the black undertail patch, use your 5B pencil and apply the graphite using firm pressure.

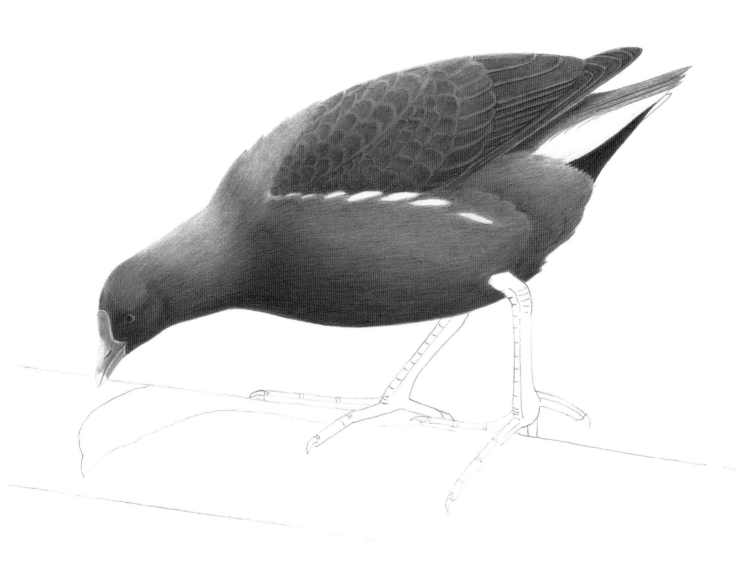

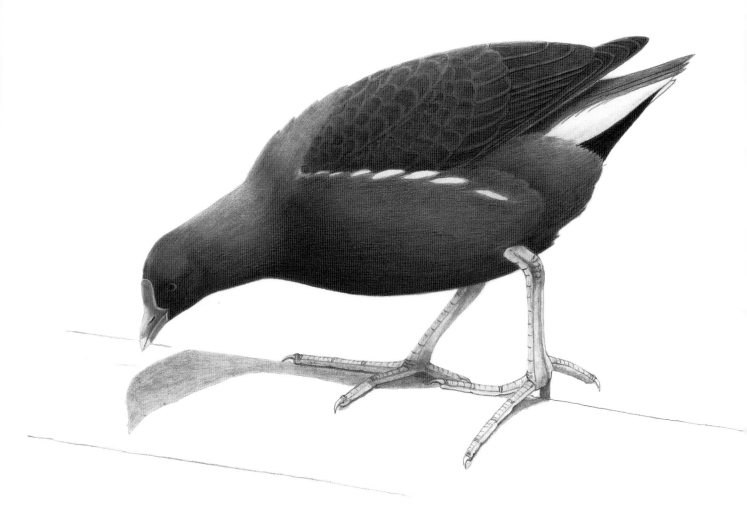

5 **Legs and feet** Using the stump that you have used to blend other areas of the drawing, fill in the area of the legs and feet. During the process of that previous blending, your stump will have picked up some graphite and that can now be reapplied to create a soft, light tone on the clean paper. Once this has been achieved, use your 2H pencil to add the detail lines on the legs and toes.

Shadows Apply more graphite to your blender by rubbing the tip on your 9B pencil and then apply this to the drawing to create the bird's shadow. As you do this, take note of the fact that the bird's right leg is in shadow and needs to be darker in tone than the left one. Also, the inner toe of the bird's right foot protrudes from beneath the shadow and so has a lighter tip. Once the shadow is in place, use your 2B pencil to add darker shadow lines beneath each of the toes.

6 **Fence rail** Before you begin working on the fence, use your stick eraser to carefully remove the outline of the bird's shadow. Next use your 2H pencil to draw numerous parallel lines along the fence rail (including through the shadow areas), to begin to create the texture and patterns on the wood. Do not worry too much about any irregularities in your lines, as these will give a more realistic appearance to the drawing. Use your blender to add more tone and texture by repeatedly drawing it along the rail in the same direction as your pencil lines. Using your 2B pencil, draw in a few deep cracks along the rail, taking care to ensure that some of them pass beneath the toes of the moorhen.

Finishing off Use your mounting putty to gently remove some graphite along the bird's back to create highlights and increase the tone in areas of shadow if you feel that they need to be darker.

Tip

Use your blender to apply graphite to create the shadow beneath the bird. This will give a more even covering of pigment and not obscure the detail that you have already drawn.

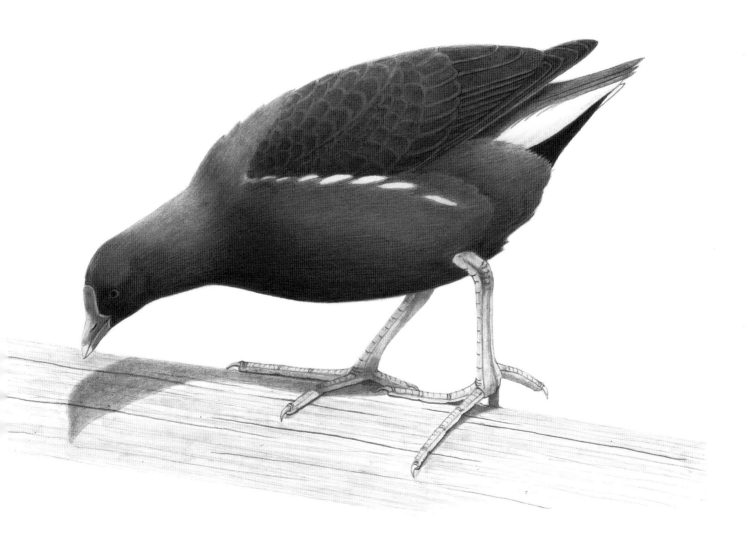

WILDFOWL

Comprising swans, geese and ducks, this group conforms to a fairly similar body shape, usually varying only in the shape of the bill, the length of the neck and their overall body size. However, there are wide variations in plumage pattern and coloration, which make them an exciting prospect for the artist.

Mute swan

Drawing a white bird on white paper presents a problem. How do we show the shape of the bird without including a hard outline that will 'flatten' the finished drawing and destroy the three-dimensional effect that we are aiming to create?

Putting in a dark background enabled me to define the shape of the swan without the need for an outline. This was then further enhanced by the addition of shadows, leaving sections of clean paper for the highlights. So, in effect, the only part of the bird that was actually 'drawn' is the area of the bill and eye.

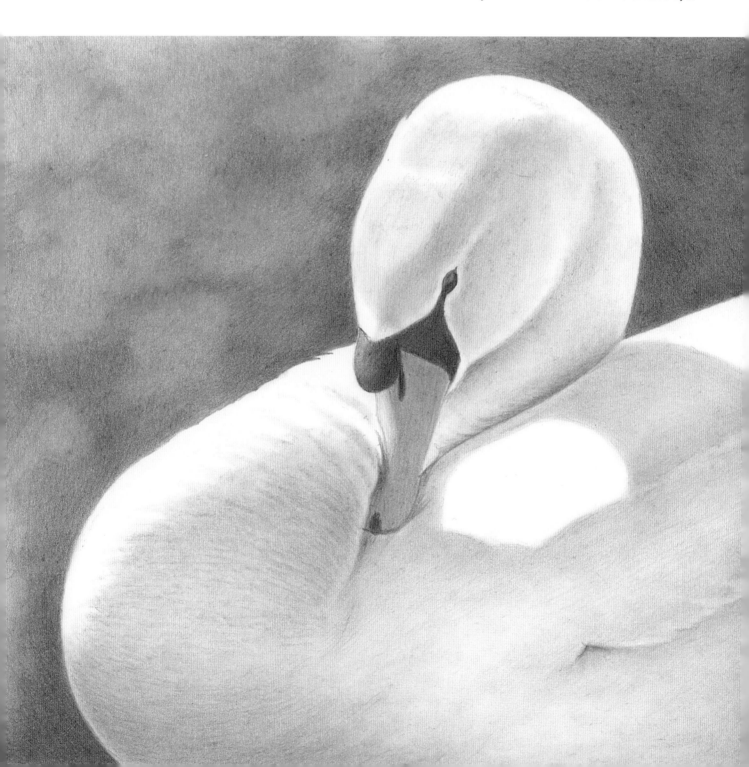

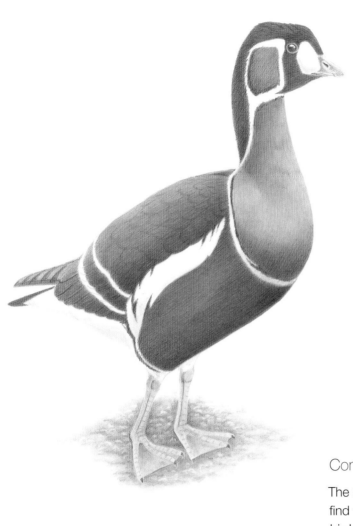

Red-breasted goose

The wonderful plumage of this beautiful goose requires the full range of graphite tones to create an accurate representation that also has a sense of form. Black, white and a mid-tone grey provide the three feather colours, while the introduction of intermediate shadow tones on the paler areas and highlights on the black plumage help to create a successful, realistic drawing.

Common eider duck

The male of this species has a striking, pied plumage that I find very appealing. As with the swan, the white areas of this bird needed to be defined without an outline, so I chose to place the eider resting on a rocky shoreline. This allowed me to delineate the bird, while also providing a more complex background to contrast with the bird's simple, bold plumage.

Canada geese

The dark heads and necks of the geese contrast beautifully with the paler back feathers to create an appealing subject for a composition.

MATERIALS

250gsm (115lb) Bristol board
2H, 2B, 5B and 9B pencils
Blending stump
Mounting putty
Stick eraser

1 **Outline** Use the outline on this page to transfer your outline to the Bristol board, or make your own version of the drawing on a separate sheet of paper and trace it (see Transferring your image to paper on page 20). Once you have transferred your drawing, it is a good idea to then redefine all the lines of your outline using light pressure and a sharp 2B pencil. Do this carefully as, if you press too hard, you will create indentations in the paper surface that might show later as you try to apply detail over them. Graphite can smudge easily, so it is a good idea to make sure that you have a second sheet of paper to lay across the drawing; rest your hand on this while you work.

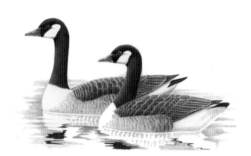

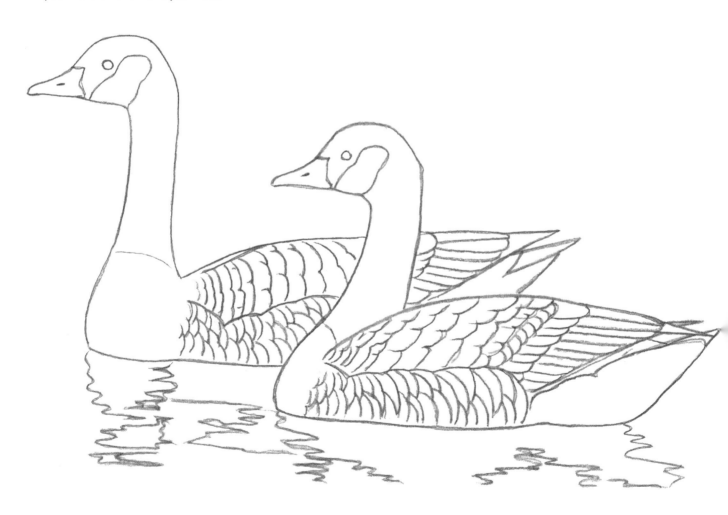

2 **Bill** Begin by laying in an even tone of graphite on the bill using a 2H pencil. Then, continuing with the same pencil, apply a second layer of graphite to create the darker areas that give the bill its shape. Use a 2B pencil to add the nostril and also the shadow line along the edge of the upper mandible.

Eye Moving on to the bird's eye, use your 2B pencil to draw the outline and to add the dark pupil in the centre, leaving a small white highlight. Once you have done this, use your stump to gently blend across the eye (avoiding the highlight). This will drag some of that soft graphite across the iris area and give it an intermediate tone.

Head and neck Still using your 2B pencil, begin to apply an even layer of graphite with parallel lines that follow the shape of the bird's body, working from bill to tail. At intervals, you can gently blend these lines to help create a soft feather-like effect, making sure that you follow the same lines with your blender as you did with your pencil. Where there are areas that are in shadow, repeat the layers of graphite to gradually build darker tones. Add some darker diagonal lines across the neck plumage to show the rougher texture of the neck feathers.

Tip

To avoid the risk of smudging the dark/soft graphite, if you are right-handed, work down the drawing from top left to bottom right (or vice versa if you are left-handed), keeping your hand away from finished areas of the drawing.

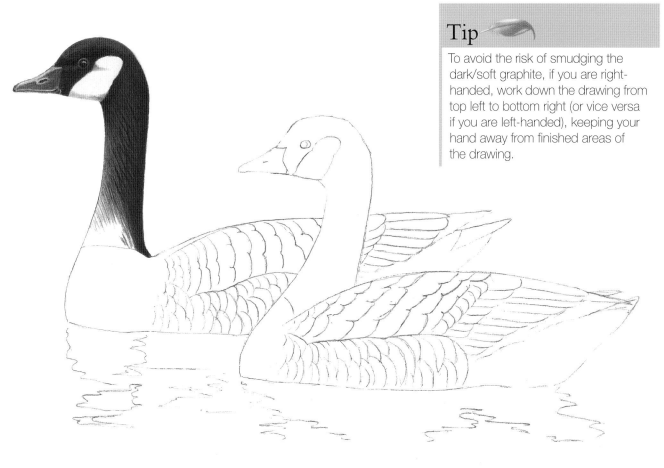

3 Complete the neck area.

Shoulder and wing The feathers on these sections of the bird's plumage are much more individually distinct, so draw in their outlines and then begin to 'fill in' each one using medium pressure and your 2B pencil. Take care to leave an untouched border around each of these feathers. When this is completed, use your 2H pencil to add the paler crescent-shaped feathers on the bird's flank.

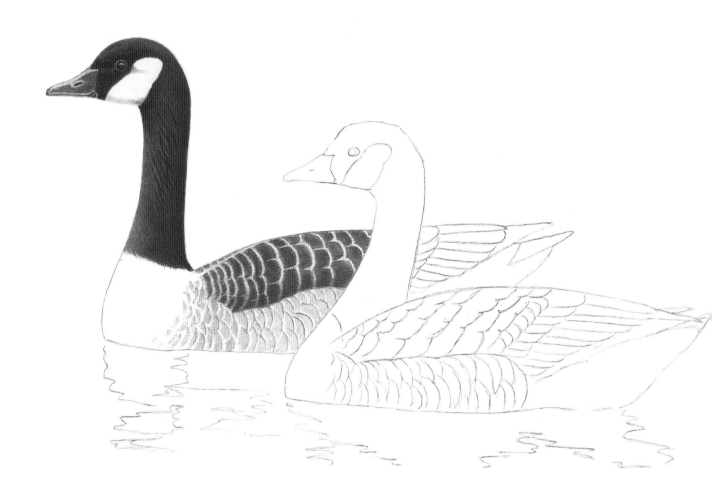

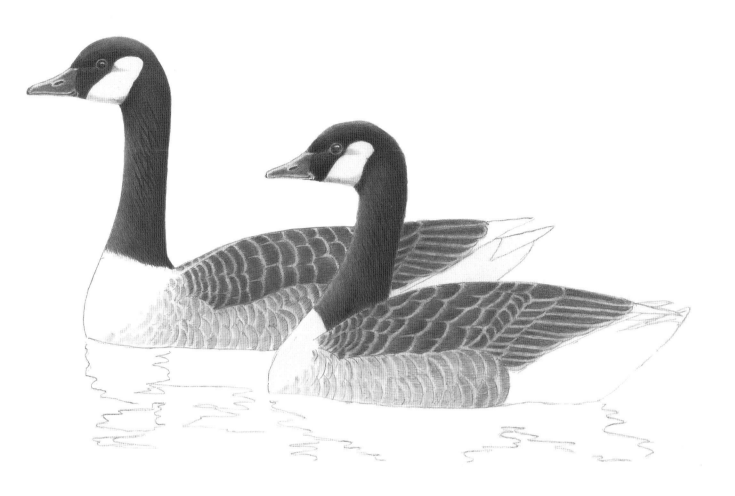

4 Repeat steps 1–3 on the foreground bird and also add tone to the rear wing feathers of the first bird.
Shoulder and wing Using your blender, gently work across the shoulder, wing and flank of both birds, following the direction of your original pencil lines to drag some of the graphite across the pale feather borders.

Head Now remove the original outline on the underside of each bird's head using your stick eraser and use your graphite-coated blender to add shadows to that area and also to the area just behind the eye.

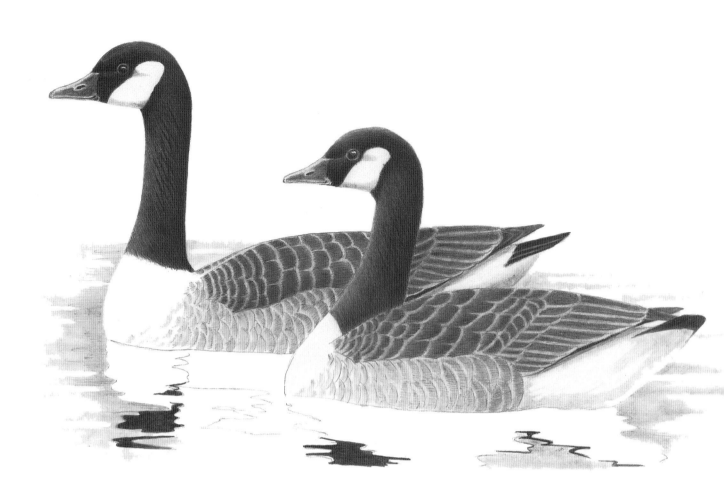

5 **Wings and tail** Use your 2B pencil
with firm pressure to draw in the tail
and primary feathers of each bird. Then
add some of the shadows beneath each
bird's tail using your blender.

Reflections Use your 2B pencil to
create some of the dark shapes within
the reflections and begin to add some of
the paler areas with your blender. Use
your stick eraser to remove any outlines
that are still present on the white areas
of the birds and allow the water tone to
define their shape.

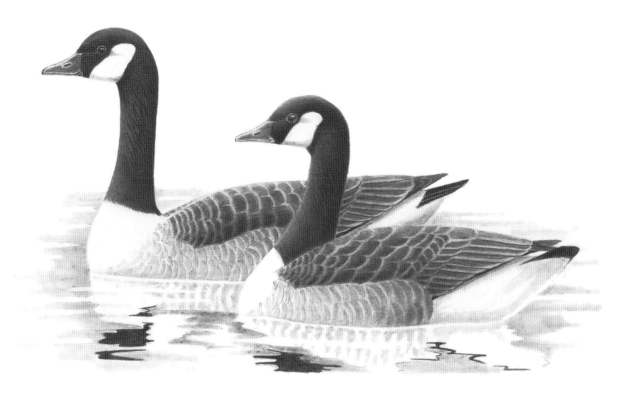

6 **Reflections** Rub your blender onto your 9B pencil and add the remaining reflections. Don't worry too much about the accuracy of these shapes and patterns, as in reality they would be changing constantly as the water moved. Once the tones and shapes have been added, use your stick eraser to drag a few white lines through these areas. This helps to show areas of bright light on the ripples created by the birds.

Birds Using your 2B pencil, add a darker tone along the lower edge of the wing feathers where they meet the flanks, and introduce some fine dark shadow lines beneath the secondary feathers at the rear of each bird's wing. Finally, use your mounting putty to lift away some of the graphite along the backs of the birds to create highlights.

SEABIRDS

Encompassing all the bird species that inhabit a maritime environment, this group is another diverse collection, but one that does have some shared characteristics.

All seabirds can swim and have webbed feet to facilitate this. For those that dive from the surface to catch fish, their feet are set far back on their bodies to provide propulsion underwater. However, this means that when they are on land they tend to stand more upright than other species. It is important to understand these variations where they occur to ensure that your drawings accurately represent the characteristics of your chosen subject.

Razorbill

In common with all the auks, this is a relatively small species, but its dark coloration, heavy bill and striking white eye stripe give it an impressive appearance.

Black-headed gull

In this drawing, I have depicted the bird in its familiar dark head plumage. Even though its name would suggest that the head feathers are black, they are in fact dark brown, so I have stopped short of creating a really dark tone on the head.

Another factor to consider when drawing this particular bird is that its plumage changes during the winter, with the dark head feathers replaced by white ones. The only evidence of the dark summer hood is a small dark spot that remains just behind the eye.

Cormorant

This bird may not be the most attractive of subjects to draw, but its almost reptilian appearance can create some interesting and challenging shapes. All members of this family have feathers with dark borders, so when you draw them, every feather can be clearly and authentically delineated.

Atlantic **puffin**

Featuring high on the list of many people's favourite birds, this species provides a combination of drawing challenges, such as creating detail and form in the dark plumage areas, soft shadows on the white feathers and correct proportions to the head and bill.

MATERIALS

250gsm (115lb) Bristol board
2H, 2B, 5B and 9B pencils
Blending stump
Mounting putty
Stick eraser

Tip

Give careful thought to the direction of the light in your composition, so that you can make best use of the resulting shadows and highlights to give a more three-dimensional finish to your drawing.

1 **Outline** First, transfer your outline to the Bristol board. You can do this either by producing your own version of the drawing on a separate sheet of paper and tracing it, or by tracing the outline on this page. Refer to the tracing method on page 20 if you are unsure about how to proceed. Once you have transferred your drawing, redefine all the lines of your outline using light pressure and a sharp 2B pencil. Do not press too hard, as you want to avoid creating indentations in your paper surface that might show later as you try to apply detail over them. To avoid the graphite smudging, make sure you have a second sheet of paper that you lay across the drawing to rest your hand on while you work.

2 **Bill** Use your 2B pencil to add tone to the two triangle shapes at the base of the puffin's bill. Then with your 2H pencil, draw in the stripes along the top and bottom of the bill, leaving three narrow segments and the border around the dark triangles untouched. Once you have done this, carefully blend over the whole bill, dragging a little graphite across the untouched segments. Finally, with your 2B pencil, draw in the dark line between the upper and lower mandibles and also add the nostril slot.

Crown Using your 5B pencil, begin to apply an even layer of graphite with parallel lines that follow the shape of the bird's body, working from bill to tail. At intervals, you can gently blend these lines to help create a soft feather-like effect, making sure that you follow the same lines with your blender as you did with your pencil. Where there is a highlight on the crown, keep the tone a little lighter. Don't worry if it appears too dark, because you can always remove some graphite later using your mounting putty.

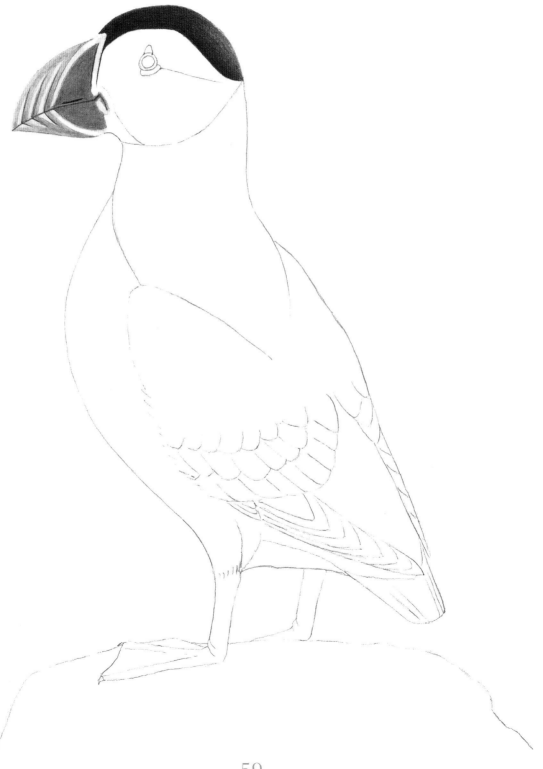

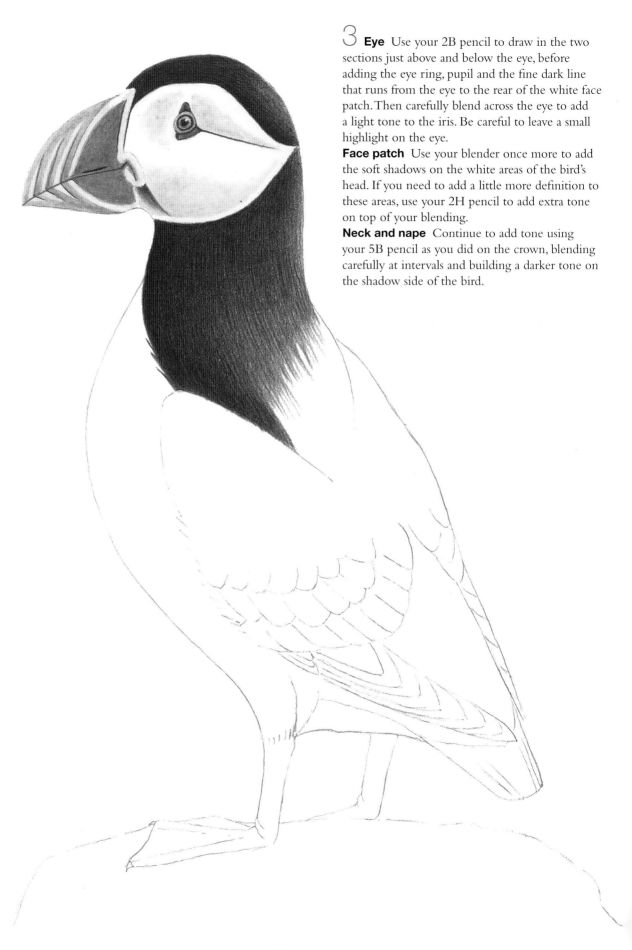

3 **Eye** Use your 2B pencil to draw in the two sections just above and below the eye, before adding the eye ring, pupil and the fine dark line that runs from the eye to the rear of the white face patch. Then carefully blend across the eye to add a light tone to the iris. Be careful to leave a small highlight on the eye.

Face patch Use your blender once more to add the soft shadows on the white areas of the bird's head. If you need to add a little more definition to these areas, use your 2H pencil to add extra tone on top of your blending.

Neck and nape Continue to add tone using your 5B pencil as you did on the crown, blending carefully at intervals and building a darker tone on the shadow side of the bird.

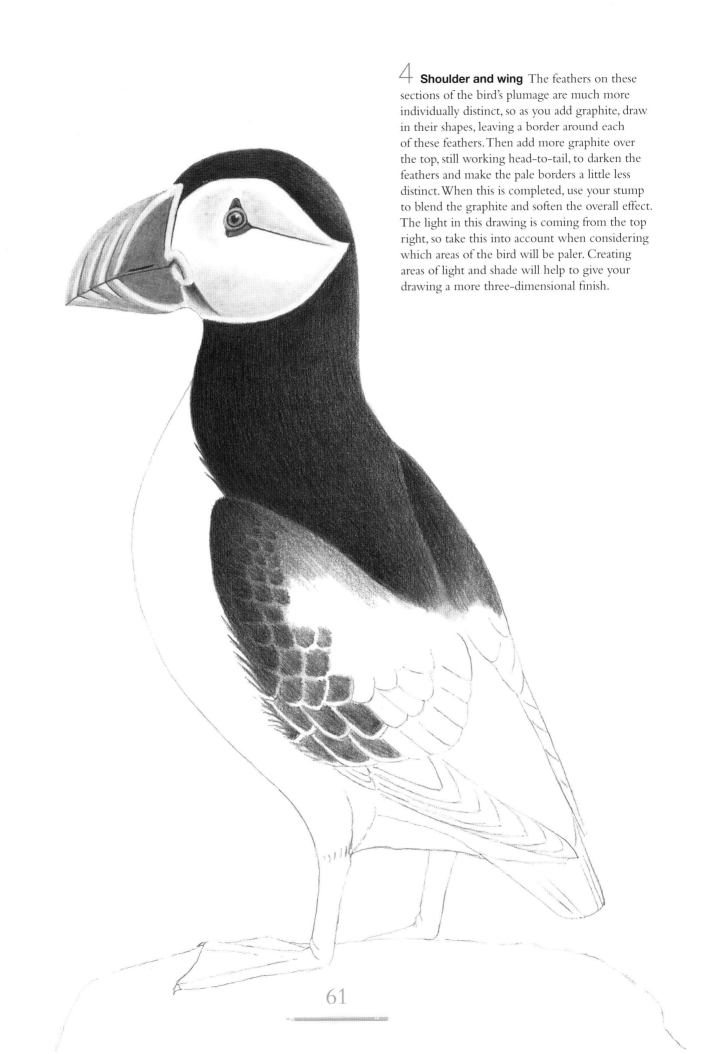

4 **Shoulder and wing** The feathers on these sections of the bird's plumage are much more individually distinct, so as you add graphite, draw in their shapes, leaving a border around each of these feathers. Then add more graphite over the top, still working head-to-tail, to darken the feathers and make the pale borders a little less distinct. When this is completed, use your stump to blend the graphite and soften the overall effect. The light in this drawing is coming from the top right, so take this into account when considering which areas of the bird will be paler. Creating areas of light and shade will help to give your drawing a more three-dimensional finish.

5 **Wings, back and tail** Continue to build the dark feather tones across the rest of the puffin's body, taking care to show the pale edges on all the wing feathers. Working with your 5B pencil means that as you blend each new section, you will draw graphite across the previously untouched areas and darken them a little. Where the wing is overlapped by fine feathers on the bird's flank, use your 5B pencil to drag some delicate lines across that edge. Once again, where there are areas in deep shadow, build really dark tones by adding numerous layers of graphite. It is always better to build slowly, so that you can create subtle changes in the tones, rather than just trying to get the darkest tone in one layer.

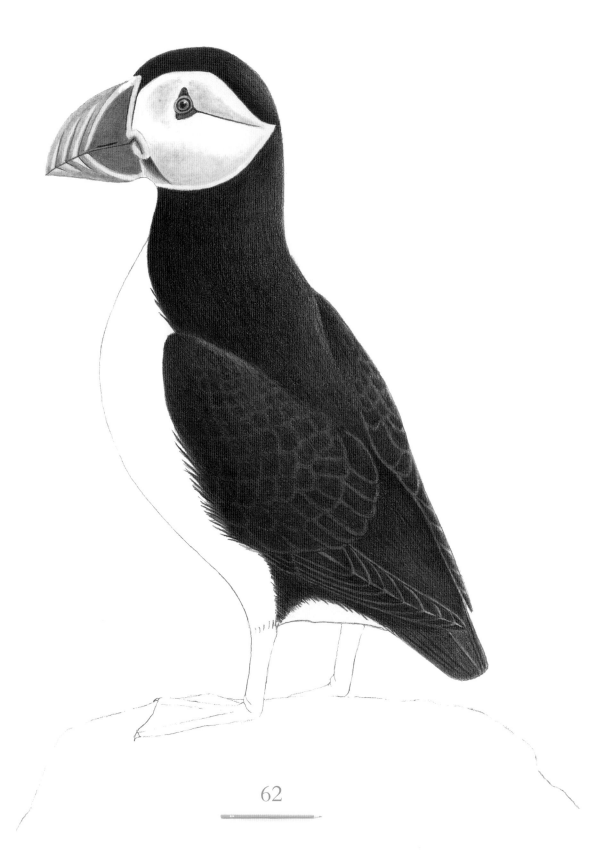

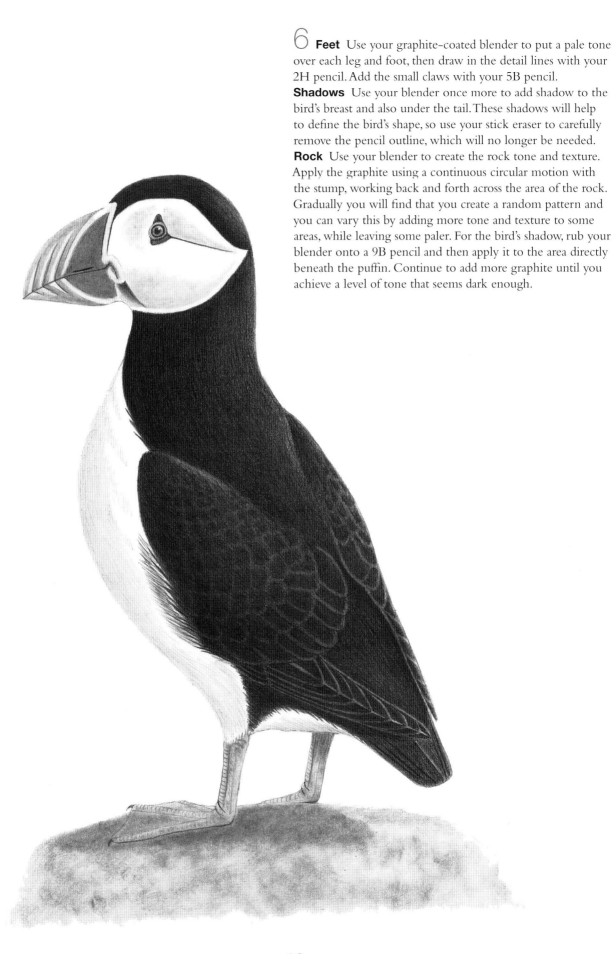

6 **Feet** Use your graphite–coated blender to put a pale tone over each leg and foot, then draw in the detail lines with your 2H pencil. Add the small claws with your 5B pencil.

Shadows Use your blender once more to add shadow to the bird's breast and also under the tail. These shadows will help to define the bird's shape, so use your stick eraser to carefully remove the pencil outline, which will no longer be needed.

Rock Use your blender to create the rock tone and texture. Apply the graphite using a continuous circular motion with the stump, working back and forth across the area of the rock. Gradually you will find that you create a random pattern and you can vary this by adding more tone and texture to some areas, while leaving some paler. For the bird's shadow, rub your blender onto a 9B pencil and then apply it to the area directly beneath the puffin. Continue to add more graphite until you achieve a level of tone that seems dark enough.

BIRDS OF PREY

Raptors are undoubtedly my favourite group of birds to draw. Each species varies in appearance, but all possess a dramatic quality that make them exciting subjects for the artist.

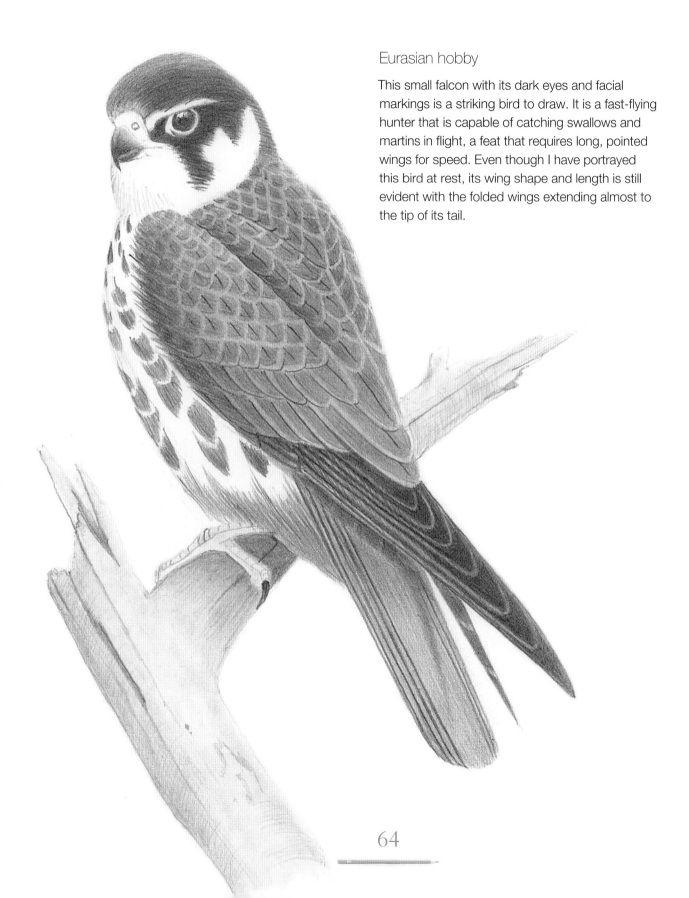

Eurasian hobby

This small falcon with its dark eyes and facial markings is a striking bird to draw. It is a fast-flying hunter that is capable of catching swallows and martins in flight, a feat that requires long, pointed wings for speed. Even though I have portrayed this bird at rest, its wing shape and length is still evident with the folded wings extending almost to the tip of its tail.

Northern goshawk

In contrast to the hobby, this goshawk is a woodland dweller with shorter wings to aid manoeuvrability within the often close confines of its wooded environment. This powerful bird can catch much larger prey than the falcon, so it is important to show the heavier build and larger bill required to achieve this.

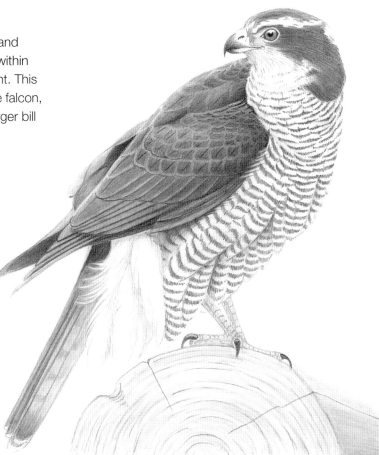

Golden eagle

The word majestic can be overused at times, but when describing this particular species, I can find no more suitable description. As I mentioned in the section on eyes (see pages 28 and 29), some raptors have a pale iris and this is true of the golden eagle. The intensity of its stare creates a sense of power, even when you cannot see the whole of the bird.

With this in mind, I chose to draw just a head and shoulders portrait with you, the viewer, as the object of the eagle's attention.

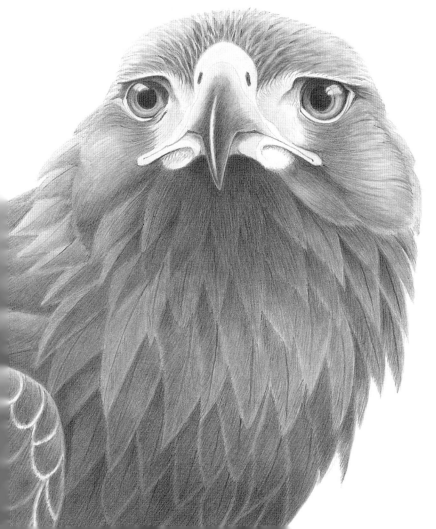

Lanner **falcon**

This drawing presents an opportunity to depict the defining
characteristics of this family of birds, such as the hooked beak, long
tapering wings and the slender toes with curved talons.

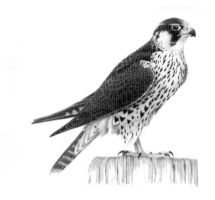

MATERIALS

250gsm (115lb) Bristol board
2H, 2B, 5B and 9B pencils
Blending stump
Mounting putty
Stick eraser

1 **Outline** First, transfer your outline to the
Bristol board. You can do this by tracing the
outline from this page, or by producing your
own version of the drawing on a separate sheet
of paper and tracing it. See the tracing method
on page 20 if you are unsure about how to
proceed. When you have transferred your
drawing, redefine all the lines of your outline
using light pressure and a sharp 2B pencil.
Do not press too hard, as you do not want to
create indentations in your paper surface that
might show later as you try to apply detail over
them. Graphite smudges easily, so make sure
that you have a second sheet of paper, which
you lay across the drawing to rest your hand
on while you work.

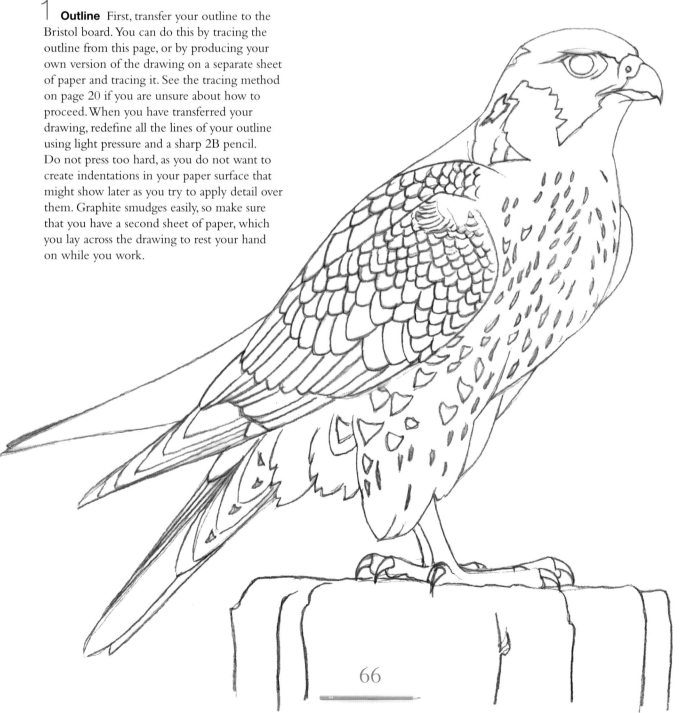

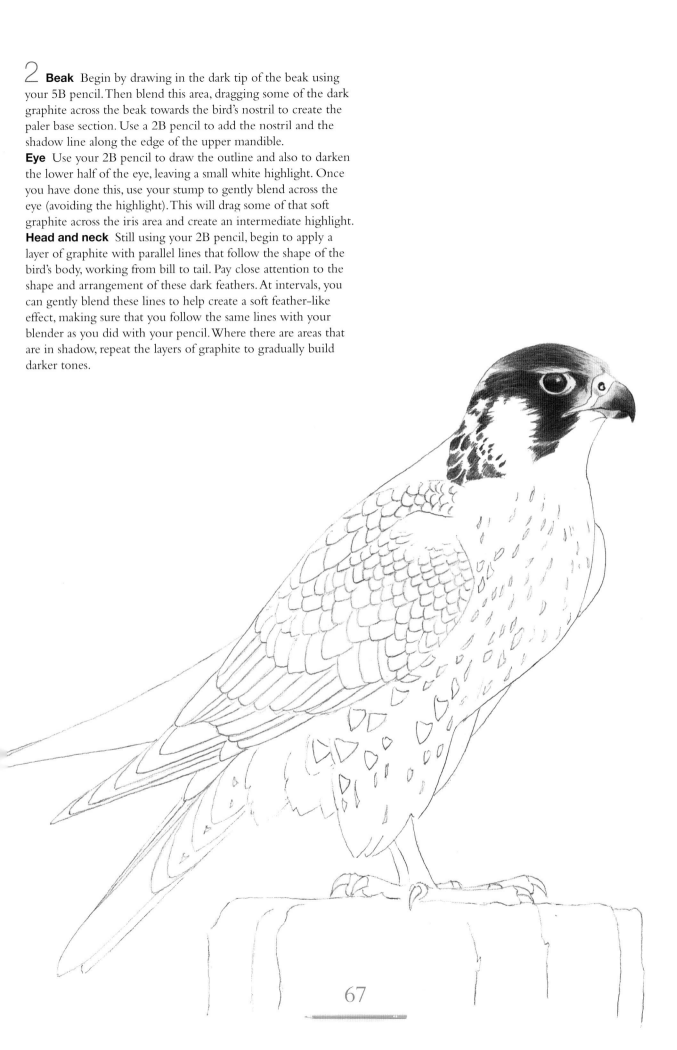

2 **Beak** Begin by drawing in the dark tip of the beak using your 5B pencil. Then blend this area, dragging some of the dark graphite across the beak towards the bird's nostril to create the paler base section. Use a 2B pencil to add the nostril and the shadow line along the edge of the upper mandible.

Eye Use your 2B pencil to draw the outline and also to darken the lower half of the eye, leaving a small white highlight. Once you have done this, use your stump to gently blend across the eye (avoiding the highlight). This will drag some of that soft graphite across the iris area and create an intermediate highlight.

Head and neck Still using your 2B pencil, begin to apply a layer of graphite with parallel lines that follow the shape of the bird's body, working from bill to tail. Pay close attention to the shape and arrangement of these dark feathers. At intervals, you can gently blend these lines to help create a soft feather-like effect, making sure that you follow the same lines with your blender as you did with your pencil. Where there are areas that are in shadow, repeat the layers of graphite to gradually build darker tones.

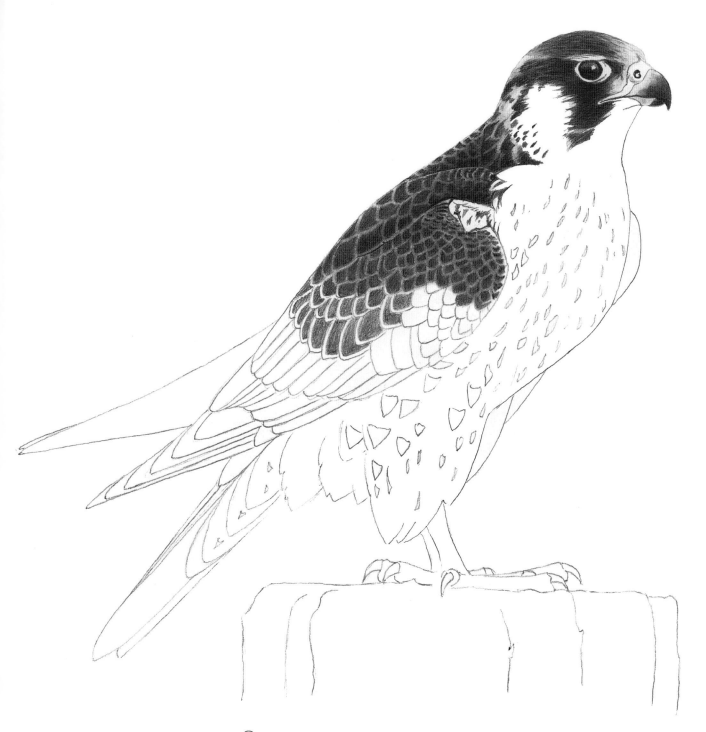

3 **Shoulder and wing** Begin to 'fill in' each feather using medium pressure and your 2B pencil. Take care to leave an untouched border around each of these feathers. As you complete each small section, gently blend over the area using strokes that follow the direction of your pencil lines. Then if you require more tone, you can darken the feathers by working over them once more with your 2B pencil. The small feathers on the upper section of the wing appear a little irregular in terms of their size and placement, but this is natural and will create a more realistic look than if they were all neatly arranged like the scales on a fish.

4 **Near wing** Complete the detail across the whole of the wing in the same way as step 3, then squeeze your mounting putty to a fine point and create the small pale sections on the secondary feathers and adjacent greater coverts (see page 24 for details of these feathers). If they look too pale, you can gently blend over this area to even out the tone.

Far wing On this wing, you are looking at the underside of the feathers, which are not as dark as they are on their upper surface, so add a pale layer of graphite with your blender. Rub your blender on your 9B pencil and apply a second layer, this time taking care to leave the pale feather edges and under-surface pattern.

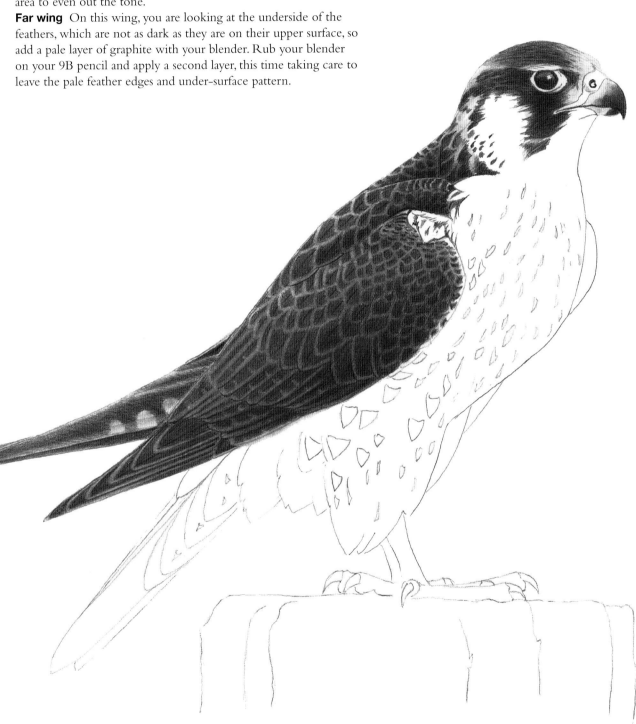

5 **Breast** Use your 5B pencil to add the dark feather detail. Take care to ensure that these streaks and spots become larger as you progress down the bird's breast, but also narrower down the right side of the drawing, where you are looking at the feathers from the side. Use your blender to add shadow tone on the breast, paying particular attention to the darker area beneath the edge of the near wing and to the shadow where the far wing is just visible, protruding from behind the breast of the bird.

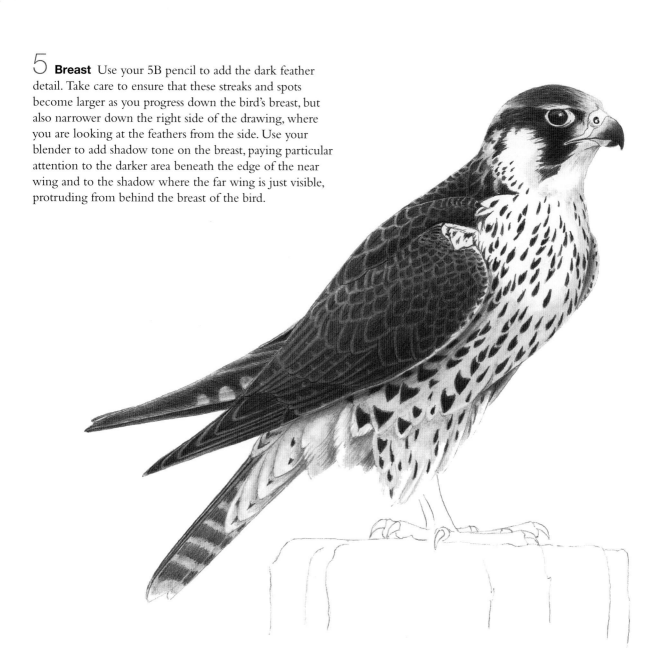

Tail Build the pattern on the tail with two layers of graphite as you did with the far wing. Using your 2B pencil, add the dark lines between the edges of the tail feathers and also the few dark spots on the under-tail plumage. Use your blender to create the shadows around these feathers.

Tip

When you are drawing the dark breast spots, ensure that you make them curved to indicate the form of the bird.

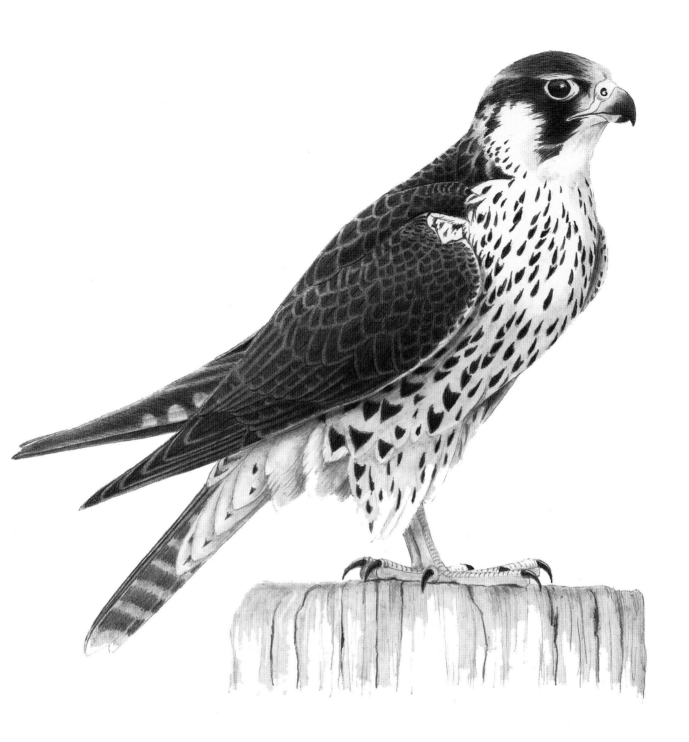

6 **Feet** Create the pale skin tone on the feet by applying a layer of graphite using the blender. Draw the detail lines with your 2H pencil and build up some shadow nearer the bird's body with another layer of blending. Add tone to the claws with your 5B pencil.

Post Create the detail on this wooden post using a combination of irregular vertical pencil lines and blending. Begin adding lines with your 2H pencil and at intervals blend some of those lines, before repeating the process several times more to build an irregular texture. Finally, add some darker lines with your 5B pencil to represent cracks in the wood.

OWLS

Owls, with their forward-facing eyes, have a more 'human-like' expression than other birds and, as such, are often cited as high on many people's list of favourite species. They do, however, present the artist with some challenges, as many have cryptic and complex plumage patterns where the individual feathers are not clearly visible and can often seem to merge together. Having a clear understanding of the plumage layout is vital in order to create a successful drawing.

Little owl

Even though this is a very small bird, the little owl's piercing eyes give it a stern expression, which is vital in accurately portraying the character of this bird. Their brown plumage is randomly peppered with white spots, so try to obtain numerous reference photos to help you depict these patterns accurately.

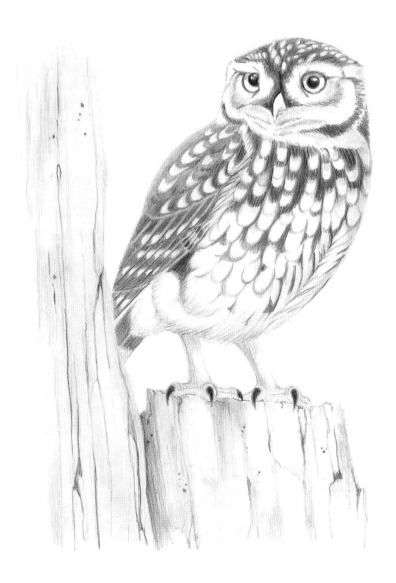

Tawny owl

In this drawing, I have purposely chosen a more unusual pose for the owl. Rather than sitting the bird upright with neat and tidy plumage, I have shown it hunched over and 'fluffed-up' in the immediate aftermath of having ruffled its feathers. Owls will often perform this exercise and then let the feathers settle back naturally to their ideal position.

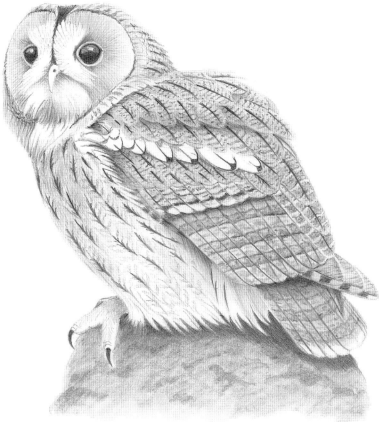

Northern hawk owl

This species with its long tail and hawk-like flight silhouette seems to fall somewhere between hawks and owls in its appearance, but the striking, dark-bordered facial disc and piercing eyes make it an interesting subject to draw.

Snowy owl

This large member of the owl family nests on the ground, so I have chosen to depict it perched on a dark rock to contrast with its pale plumage.

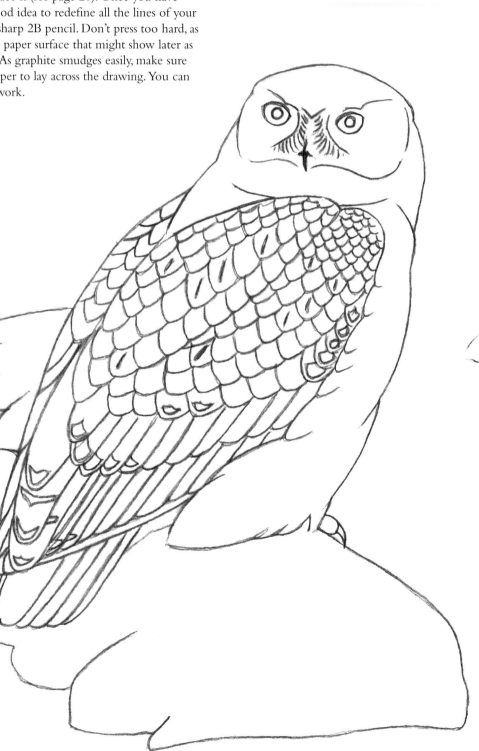

1 **Outline** Use the outline on this page to transfer your outline to the Bristol board. Alternatively, make your own version of the drawing on a separate sheet of paper and trace it (see page 20). Once you have transferred your drawing, it is a good idea to redefine all the lines of your outline using light pressure and a sharp 2B pencil. Don't press too hard, as you will create indentations in the paper surface that might show later as you try to apply detail over them. As graphite smudges easily, make sure that you have a second sheet of paper to lay across the drawing. You can rest your hand on this while you work.

MATERIALS

250gsm (115lb)
Bristol board
2H, 2B, 5B and 9B pencils
Blending stump
Mounting putty
Stick eraser

2 **Beak** Begin by drawing in the dark beak using your 5B pencil. Make the edges of the beak irregular to indicate where it will be overlapped by some of the facial feathers.

Eyes Use your 5B pencil to draw the eye ring around each eye and to add the black pupil. Blend across the eye, leaving a small white highlight, and then create a shadow on the top half of the eye by rubbing your blender on your 9B pencil, before applying the extra graphite to the shadow area. Take care not to blend over the highlight.

Face and head Begin to define the shadows around the eyes and facial disc using your 2H pencil, ensuring that your pencil lines radiate out from the eyes. Add a darker tone with your 2B pencil to the dark shadows between the eyes and the feathers on either side of the beak. Add a few dark spots on the crown with the same pencil. Introduce the shadows and feather detail on the crown of the head and around the facial disc with your 2H pencil.

3 **Wings and body** Gradually move down the owl's body and wing, adding shadows with your 2H pencil. Add a few dark feather patches with your 5B pencil and begin to create highlights by lifting off some of the feather shapes with your mounting putty. Take care to ensure that you do not remove all the feather outlines. Squeeze your putty to a blunt point and gently dab the lines repeatedly until you have made them less distinct. Use this same technique to lighten the outline along the left shoulder and wing.

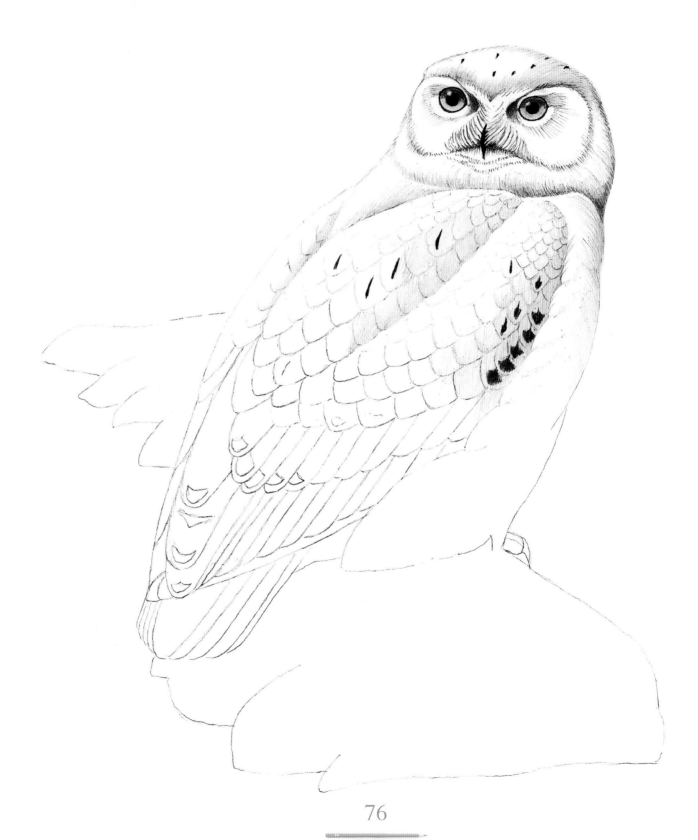

Tip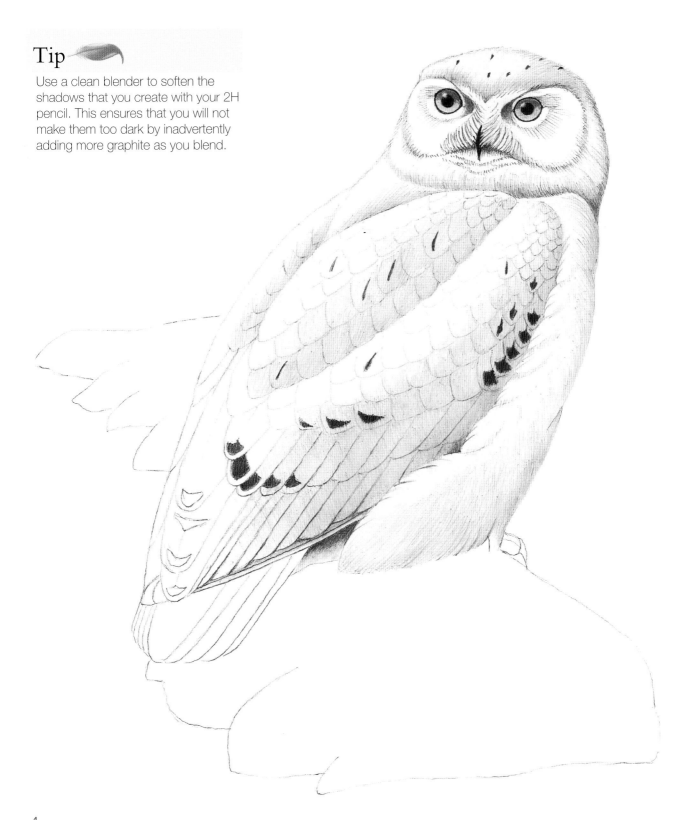

Use a clean blender to soften the
shadows that you create with your 2H
pencil. This ensures that you will not
make them too dark by inadvertently
adding more graphite as you blend.

4 **Wing** Continue to work down the wing, adding shadows with your 2H
pencil. Introduce more of the dark feather patches with your 5B pencil and
also add the dark shadow lines between the primary and secondary feathers.
Using the 2B pencil, add the dark shadow beneath the wing and tail.

77

5 **Wing, tail and toe** Complete the pale (2H) shadows across the wing and then on the tail, adding the remaining dark feather patches with your 5B pencil as before. Use the 5B pencil to draw the dark talon and the 2H to add the fine toe feathers.

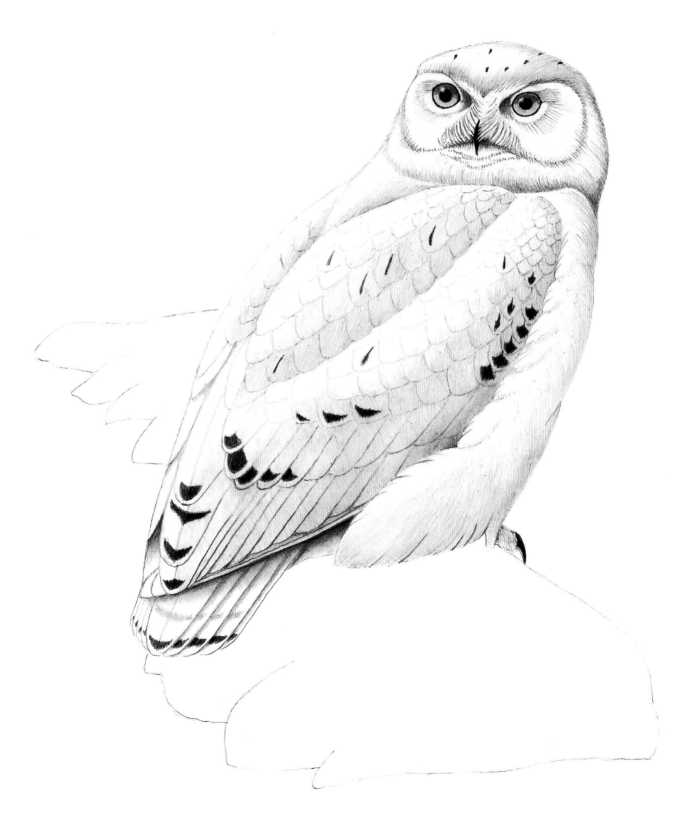

6 **Rock and shadows** Use a circular technique to apply graphite with your blender to the rock surface. Build up the texture by working back and forth across the paper. Add extra (9B) graphite to the blender and darken the shadows where there are indentations along the left-hand edge of the rock and also to the area where the bird's shadow falls. Take your stick eraser and use it to lighten the upper surface of the rock where the highlights fall. Finally, darken the rock immediately beneath the bird with your 5B pencil.

GARDEN AND WOODLAND BIRDS

Some of the birds in this group can be counted among our most recognizable species, but that familiarity brings with it certain traps and pitfalls. Just because we may be able to quickly and easily recognize a bird that we see daily in our garden, does not mean that we have necessarily identified and understood all the various characteristics of that species. Close observation is vital if we are to create accurate drawings of any species, however familiar it may be.

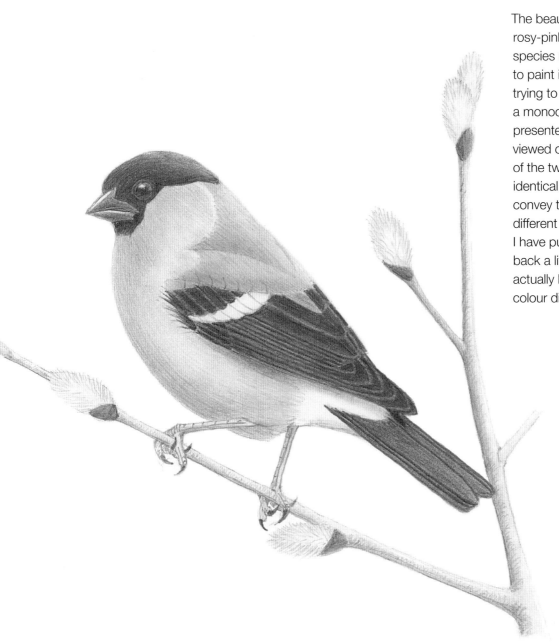

Eurasian bullfinch

The beautiful slate grey back and rosy-pink breast of the male of this species make it a wonderful bird to paint in colour. However, when trying to recreate those hues in a monochrome drawing, we are presented with a problem. When viewed on the greyscale, the values of the two colours are almost identical, but we have to somehow convey the fact that they are different hues. So in this drawing, I have purposely made the bird's back a little darker than it should actually be, to suggest that subtle colour difference.

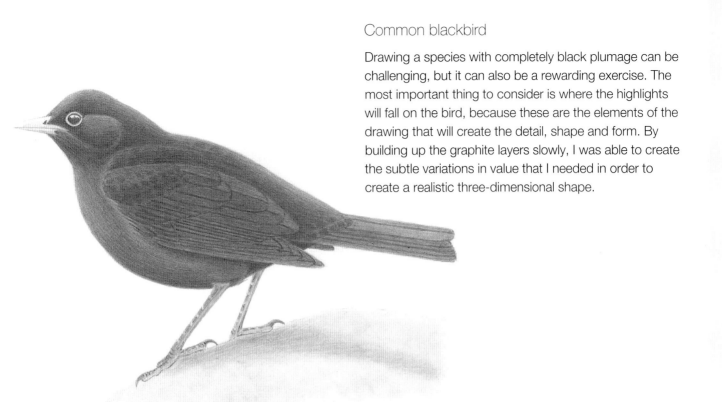

Common blackbird

Drawing a species with completely black plumage can be challenging, but it can also be a rewarding exercise. The most important thing to consider is where the highlights will fall on the bird, because these are the elements of the drawing that will create the detail, shape and form. By building up the graphite layers slowly, I was able to create the subtle variations in value that I needed in order to create a realistic three-dimensional shape.

Great spotted woodpecker

I have added a little more habitat in this drawing to show the advantages of choosing the right background for your bird drawings. The silver birch trunk has some dark shapes and patterns on its surface that are not unlike the black plumage patterns on the woodpecker's head. This visual connection helps to make the bird appear a much more authentic part of the scene.

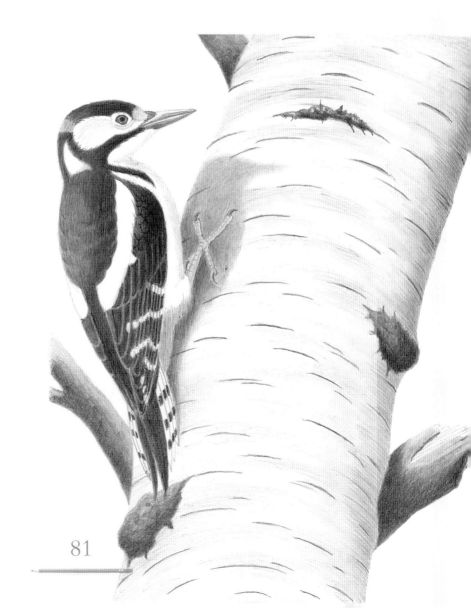

European goldfinch

This delicate and attractive species can often be a regular visitor to our gardens. Its fine beak is ideally suited to probing for the seeds that form its diet.

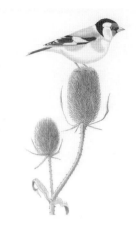

MATERIALS

250gsm (115lb)
Bristol board
2H, 2B, 5B and 9B pencils
Blending stump
Mounting putty
Stick eraser

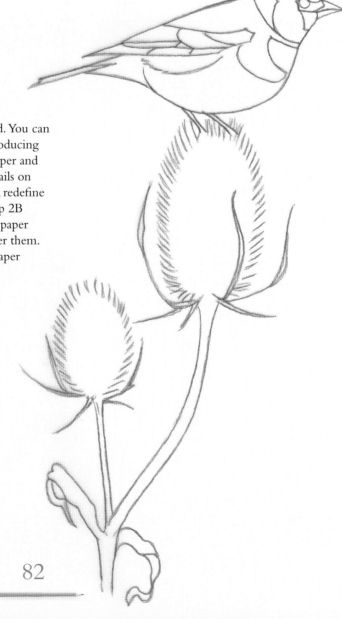

1 **Outline** First, transfer your outline to the Bristol board. You can do this either by tracing the outline on this page, or by producing your own version of the drawing on a separate sheet of paper and tracing it. Refer to the tracing method on page 20 for details on how to proceed. Once you have transferred your drawing, redefine all the lines of your outline using light pressure and a sharp 2B pencil. Press lightly to avoid creating indentations in your paper surface that might show later as you try to apply detail over them. To avoid the graphite smudging, place a second sheet of paper across the drawing to rest your hand on while you work.

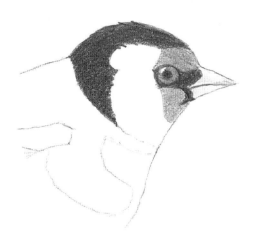

2 **Head** Using your 5B pencil, fill in the black area on the bird's crown and also the patch in front of the eye. With the same pencil, draw in the eye ring and pupil, then blend across the eye to darken the iris. Take care to leave a small highlight on the upper left side of the eye. Use your blender to gently add a light tone to the beak.

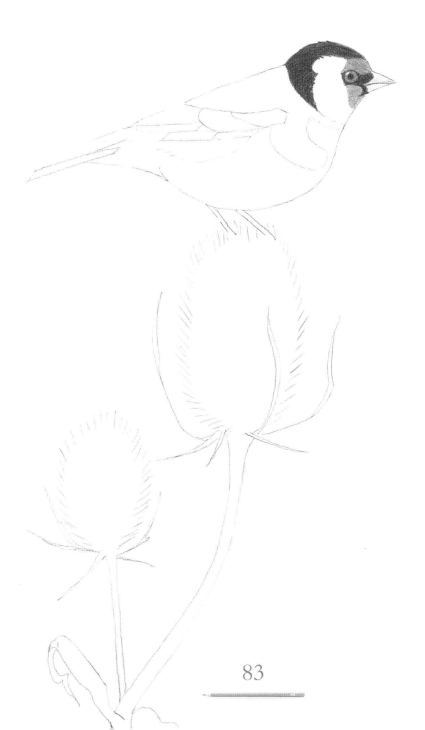

3 **Cheek** Add a pale area of tone to the cheek of the goldfinch with your 2H pencil.
Back Apply a pale tone to the bird's back using your 2H pencil, ensuring that your pencil lines follow the head-to-tail direction. Using a little more pressure, apply a second layer on the lower edge of this section to indicate the shadow area created by the curve of the bird's body. Create the chest patch by using your 2H pencil again, but this time using lighter pressure to achieve a tone that is paler than that on the bird's back.

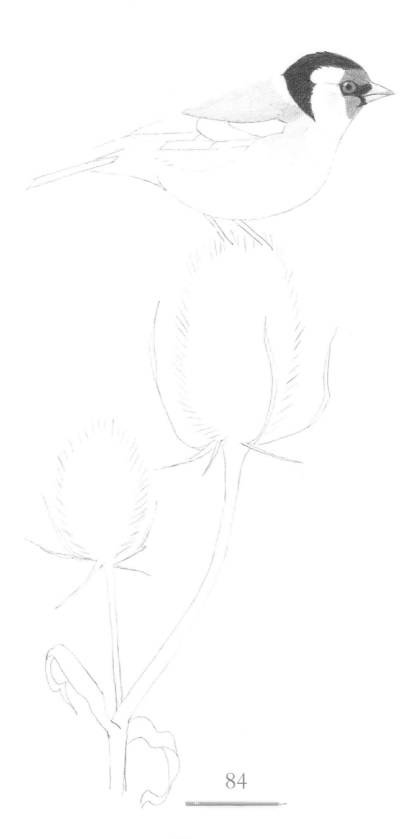

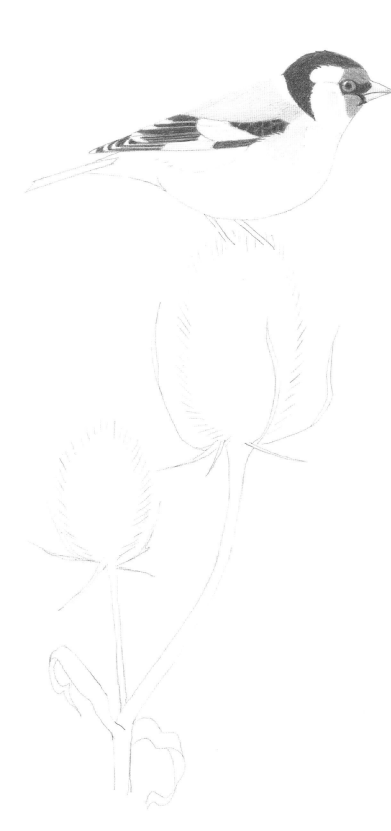

4 **Wing** Use your 5B pencil to fill in all the wing feathers. Leave the three larger wing patches (which are 'gold' in colour) clean and also a small white spot at the tip of each feather.

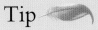

Tip

Make sure to leave a pale line around the main dark wing feathers. These areas can then be darkened slightly by gently rubbing with an impregnated blender.

5 **Tail** Use your 5B pencil to draw in the tail feathers and make sure that you leave a white tip to each one.

Body Draw in the pale patch on the bird's flank using your 2H pencil. This should be the same level of tone as the chest patch added in step 2. Apply a delicate shadow line to the underside of the bird's body using the blender and then use your stick eraser to remove your original pencil outline.

Legs and feet Use your blender to give a pale tone to the legs and then add the detail lines over this with your 2H pencil. Draw in the toes and add detail in the same way.

Teasel head Start to build the detail using your 2B pencil by drawing in successive bands of detail lines that curve up toward the top of the seed head. Overlap the feet of the goldfinch with these lines to give the effect of the toes being down among the 'spines' of the teasel.

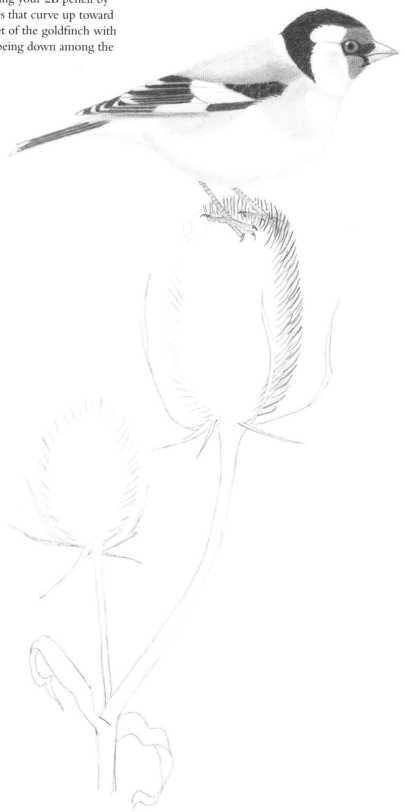

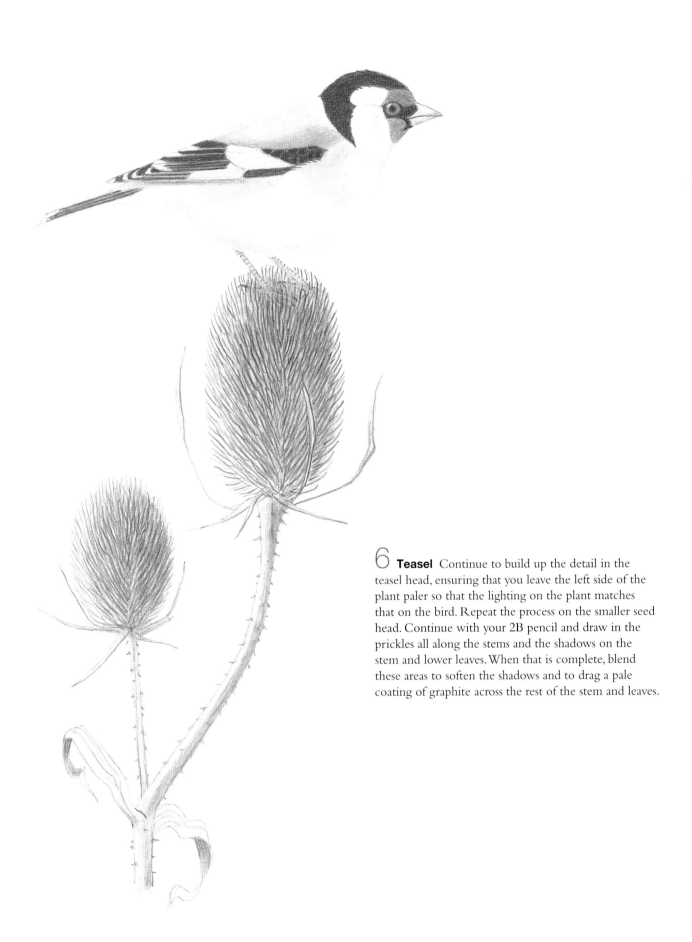

6 **Teasel** Continue to build up the detail in the teasel head, ensuring that you leave the left side of the plant paler so that the lighting on the plant matches that on the bird. Repeat the process on the smaller seed head. Continue with your 2B pencil and draw in the prickles all along the stems and the shadows on the stem and lower leaves. When that is complete, blend these areas to soften the shadows and to drag a pale coating of graphite across the rest of the stem and leaves.

GAME BIRDS

This final group contains birds that predominately spend most of their lives on the ground. They can fly for relatively short distances and possess the short, rounded wings that are needed for rapid take-off, but they will also run for cover more readily than most other birds and so their legs and feet are short and strong.

Common quail

This small bird has complex, cryptic plumage and is often difficult to see in the wild, but nevertheless it is an interesting subject for the bird artist. The irregular pattern of muted browns is punctuated at intervals by streaks of pale cream, and the striking head pattern of the male adds an interesting element to the bird's overall appearance.

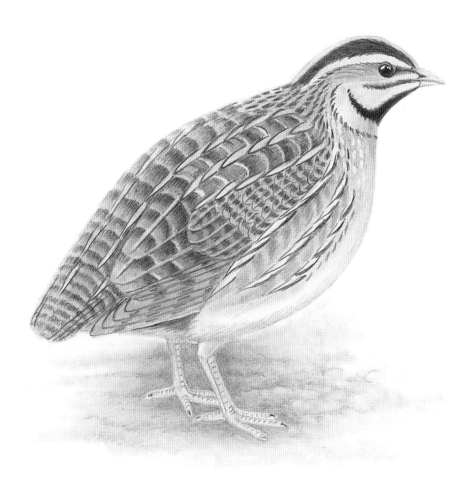

Red grouse

In this drawing, I chose to depict the male of the species, which is darker in colour than the female and sports a small red comb on the crown of its head above each eye. The plumage is very complex, but need not be too daunting if you work on a small section at a time.

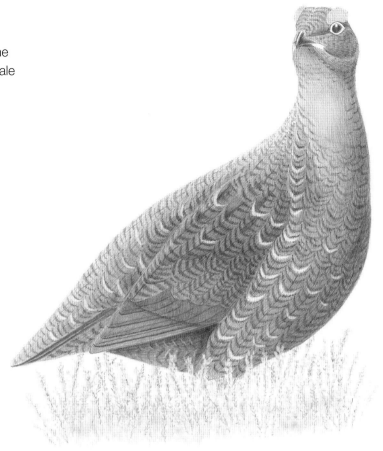

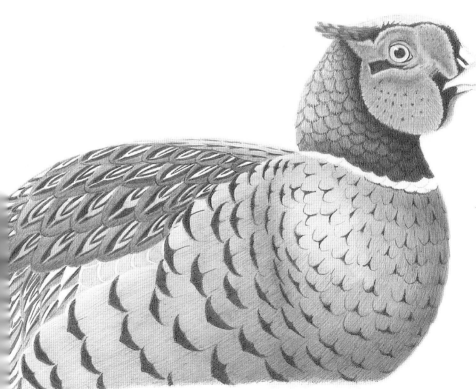

Common pheasant

This is a very familiar bird with a bold and distinctive plumage. However, in contrast to the quail and grouse, the different feather patterns are arranged in clearly defined sections and the individual feathers are much easier to see, making the drawing process a little easier.

Red-legged partridge

Although this bird's plumage patterns might at first appear complicated, each variation is clearly defined, making the drawing process easier.

1 **Outline** Transfer your outline to the Bristol board, either by producing your own version of the drawing on a separate sheet of paper and tracing it, or by tracing the outline from this page. Refer to the tracing method in the 'How to start' section if you are unsure about how to proceed. Once you have transferred your drawing it is a good idea to then redefine all the lines of your outline using light pressure and a sharp 2B pencil. Do not press too hard, as you do not want to create indentations in your paper surface which might show later as you try to apply detail over them. As graphite can smudge easily it is a good idea to make sure than you have a second sheet of paper which you lay across the drawing to rest your hand on while you work.

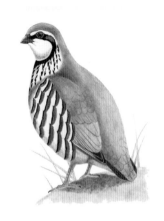

MATERIALS

250gsm (115lb) Bristol board
2H, HB, 2B, 5B and 9B pencils
Blending stump
Mounting putty
Stick eraser

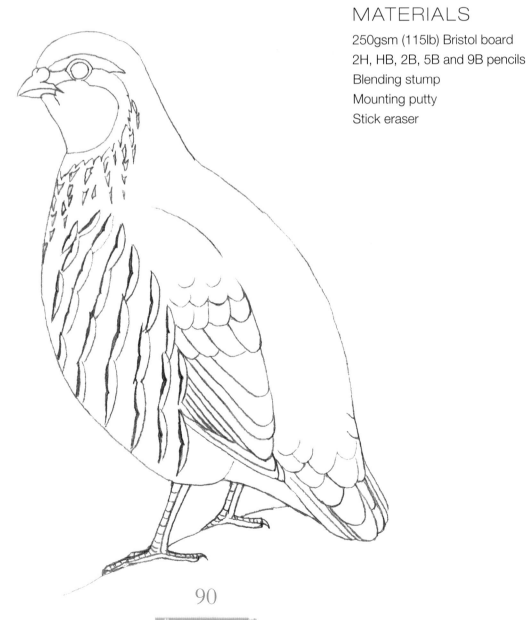

2 **Head** Use your 2B pencil to draw in the beak and the 'spectacle' ring around the eye. Then with your 5B pencil, outline the eye and put in the pupil. Blend across the eye to darken the iris area, taking care to leave a white highlight. Use your 5B pencil to add the dark facial stripe and the speckles on the neck and breast. Leave a paler area in this black stripe just behind the eye and introduce some fine detail lines into this patch. Use your blender to add a shadow on the throat area. Begin to add tone to the crown with your HB pencil, taking care to keep your pencil lines flowing from 'beak to tail'.

Tip

As you begin to add graphite to the head and body, think carefully about the shape of the bird. Graduate the level of tone to indicate that you are depicting a curved surface.

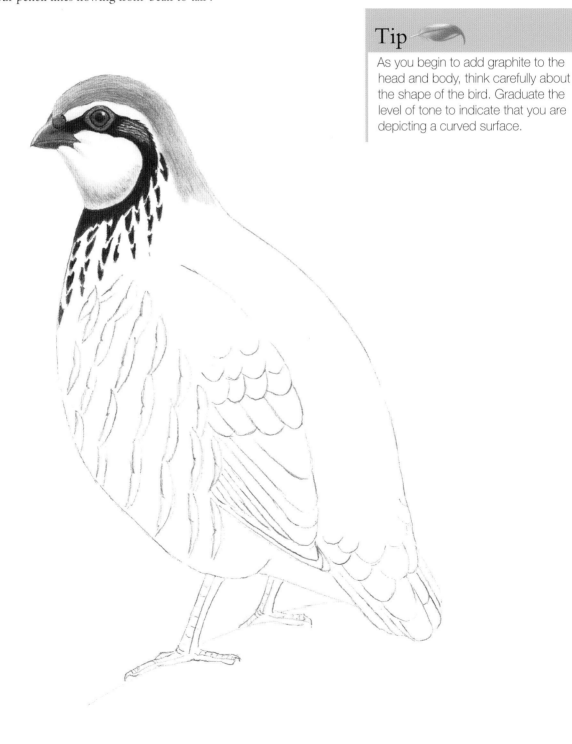

3 **Upper wing, body and tail** Continue with your HB pencil, gradually working down the bird's body. Build up the level of tone on the shoulder, upper breast and beside the tail, to give form to the bird. On the lower sections of the wing and tail delineate a few of the feathers where they are larger and more obvious. Don't forget that you can use your mounting putty to lift off a little graphite from any areas where you find that your tonal layer is too dark. Use your 2B pencil to draw in the darker, outer tail feathers.

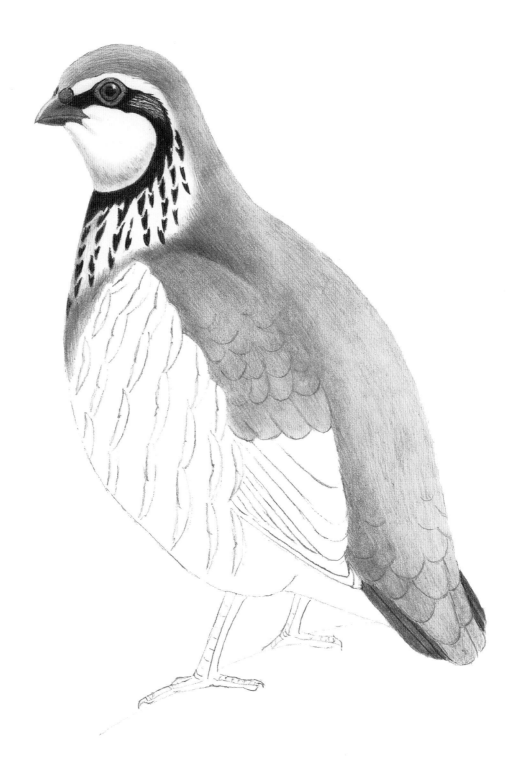

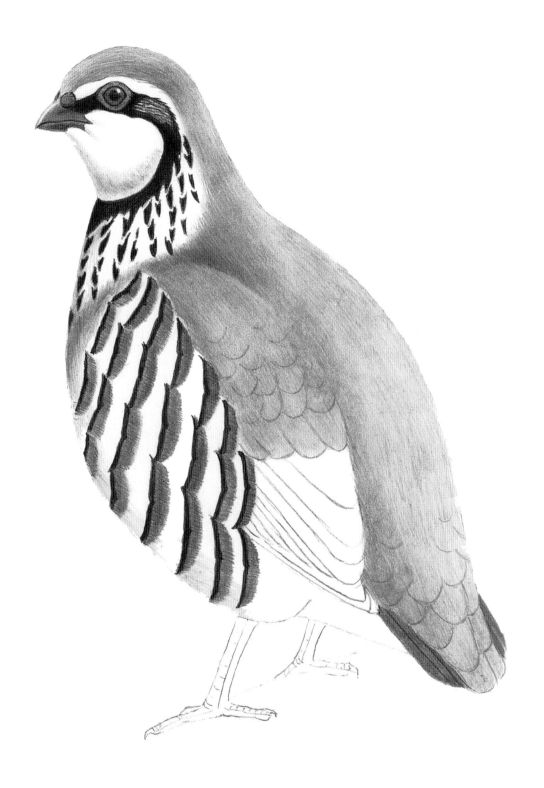

4 **Flank** Use your 5B pencil to draw in the black feather stripes on the flank and then complete the coloured tips to these feathers using your 2B pencil. Create a delicate shadow all along the underside of the breast using your blender.

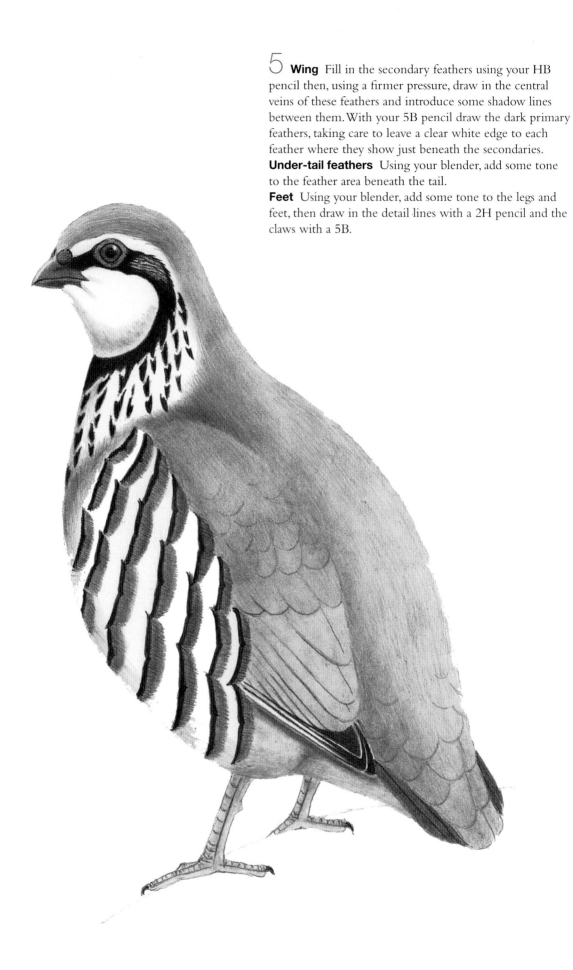

5 **Wing** Fill in the secondary feathers using your HB pencil then, using a firmer pressure, draw in the central veins of these feathers and introduce some shadow lines between them. With your 5B pencil draw the dark primary feathers, taking care to leave a clear white edge to each feather where they show just beneath the secondaries.

Under-tail feathers Using your blender, add some tone to the feather area beneath the tail.

Feet Using your blender, add some tone to the legs and feet, then draw in the detail lines with a 2H pencil and the claws with a 5B.

6 **Rock and grass** Create the stone texture using a circular application with your blender. Work back and forth until you achieve an irregular pattern in the graphite. Where the partridge is casting a shadow, rub your blender on your 9B pencil and apply it to the drawing to darken the tone. Use your 2H pencil to draw in a few random blades of grass to complete the composition.

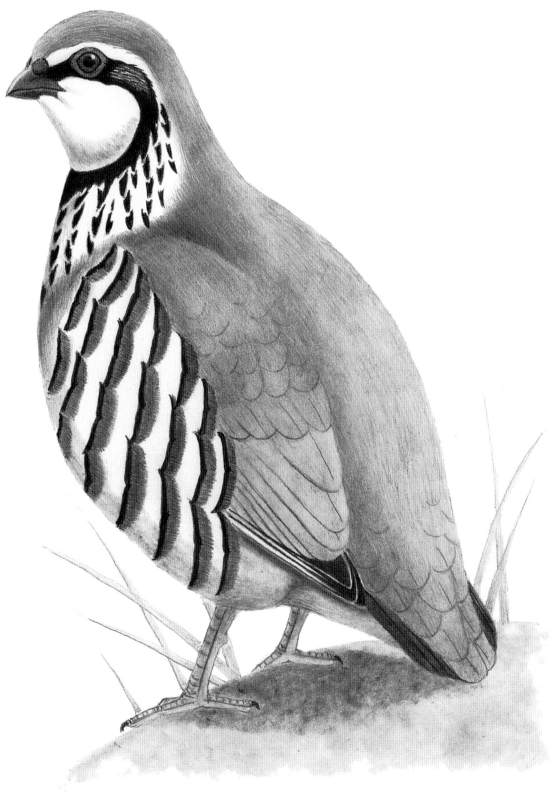

Index